BACK HOME AGAIN

Indiana in the Farm Security Administration Photographs, 1935–1943

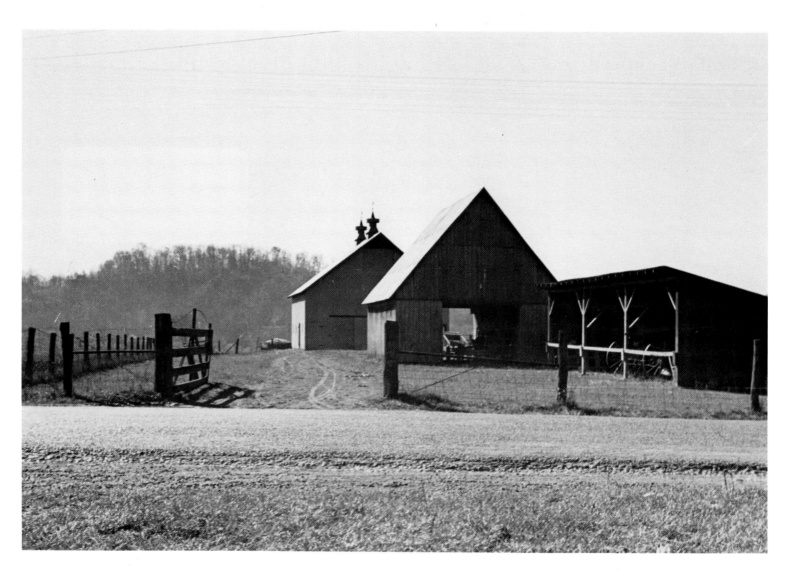

LC-USF 4053–M1 *Theodor Jung.*

BACK HOME AGAIN

Indiana in the Farm Security Administration Photographs, 1935–1943

EDITED BY

Robert L. Reid

INDIANA UNIVERSITY PRESS
Bloomington and Indianapolis

Manufactured in the United States of America

Library of Congress Cataloging-in-Publication Data
Back home again.
Bibliography: p.
1. Indiana—Description and travel—Views.
2. Indiana—Social life and customs—Pictorial works.
I. Reid, Robert L., 1938– . II. United States.
Farm Security Administration.
F527.B33 1987 977.2′042 86–46377
ISBN 0–253–31133–0

0–253–21246–4 (pbk.)

CONTENTS

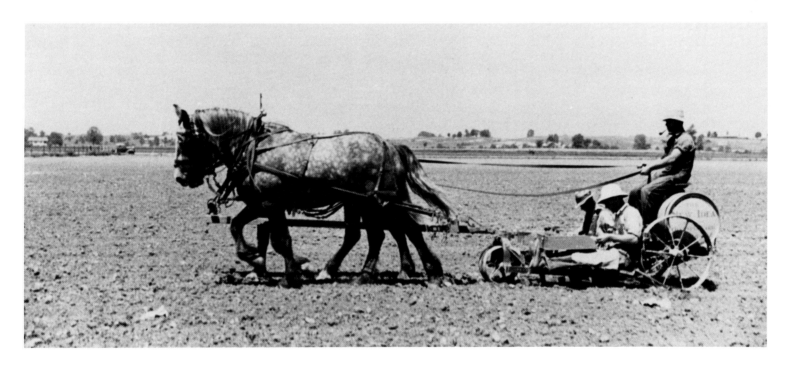

LC-USF 2788–M4 *Arthur Rothstein.*

PREFACE

THIS BOOK is an album of photographs taken in Indiana from 1935 to 1943. Like the rest of the nation, Hoosiers faced the challenges of the Great Depression and World War II during those years. An obscure New Deal agency called the Historical Section of the Farm Security Administration photographed a broad spectrum of American life, focusing on the one-third of the population President Franklin D. Roosevelt described as "ill-housed, ill-clad, ill-nourished." The collection that resulted, which includes these Indiana images, is located in Washington, D.C.

My interest in these FSA photographs goes back to 1983 when, browsing through the Prints and Photographs Division at the Library of Congress, I found Russell Lee's images of the aftermath of the Great Flood of 1937 in Posey County. Encouraged by David Horvath, Associate Curator of the University of Louisville Photographic Archives, my interest expanded to the entire set of Indiana pictures. I was impressed by the quality of the selection, the geographical distribution of the photographs, and the representation of seven of the eleven major FSA staff photographers.

One result was an exhibit for Hoosier Celebration '88, a statewide program to celebrate the richness of our past and the promise of our future. This Indiana FSA exhibit will also be available for public display in 1989, the 150th anniversary of the invention of photography. A grant from the Indiana Committee for the Humanities, together with the enthusiastic support of John Streetman, Director of the Evansville Museum of Arts and Science, Lee Scott Theisen, Executive Director of the Indiana State Museum and Historic Sites, and David L. Rice, President of the University of Southern Indiana, has made the exhibit a reality.

Several county historians, including Dorothy Bailey (Brown), Dick D. Heller, Jr. (Adams), and Norbert Smith (Martin), assisted me in the research, as did Rolla Garrett of Burns City. Library and media staff at the Library of Congress, the University of Louisville Photographic Archives, the Indiana State Library, and the University of Southern Indiana were helpful and supportive. Special thanks go to Beverly Brannan and Leroy Bellamy at the Library of Congress to Larry Ordner, Coordinator of Media Services at USI, and to Lenny Dowhie, Charles Price, and Erik Reid for their help in reviewing the photographs. John Gallman, Bobbi Diehl, and Tarry Curry at the Indiana University Press were exemplary colleagues in the preparation of this book. My greatest debt, however, is to those many Hoosiers who cooperated with the men and women behind the cameras.

A Note on the Captions

The original captions from the Library of Congress have been used in most cases. They were taken from information provided by the photographers, although they may have been edited by Stryker or his staff in Washington, D.C. However, in the interest of brevity, some have been shortened.

The number on each caption enables one to locate the desired photograph at the Library of Congress, Prints and Photographs Division.

Introduction

... Whenever they asked me, "What are you doing out here taking pictures?" I said, "Well, I'm taking pictures of the history of today." And they understood this. And this was an entree to the people that were difficult to communicate with. . . . I sort of felt, too, that by means of these pictures, we were helping some . . . parts of the country understand what the other parts were like."

—Russell Lee, 1964

THE PICTURES OF INDIANA taken by Russell Lee and his colleagues provide a striking visual memory of what the Hoosier state was like fifty years ago. As the selections in this book attest, the Farm Security Administration photographers captured on film a rich panorama of daily life. In a manner reminiscent of a family album, these photographs record the experiences of a state and nation in the midst of profound change. The impact of two transforming events, the Great Depression and World War II, is reflected in the faces of the people portrayed at home in Indiana.

Russell Lee was one of a number of photographers who visited the state for the FSA in the years from 1935 to 1943. Chosen by the federal government because of their photographic skills, the FSA photographers were to provide documentary evidence of the work of federal agencies concerned with the plight of the rural poor. The project originated with the Resettlement Administration (RA), which was created in 1935 to help those who were being overlooked by the major New Deal farm agency, the Agricultural Adjustment Administration. When two years later the RA was absorbed into the Department of Agriculture, it was renamed the Farm Security Administration (FSA).

Rexford G. Tugwell, a member of President Roosevelt's "Brain Trust," was appointed administrator of the RA. One of Tugwell's first acts upon assuming office was to ask his friend and former colleague at Columbia University, an economics instructor named Roy Emerson Stryker, to head the Historical Section—the RA's special unit charged with directing "the activities of investigators, photographers, economists, sociologists, and statisticians." Given Stryker's interest in photography, the Historical Section in fact concentrated on visual representation.

While Stryker was not himself a photographer, he proved to be an excellent administrator for the project. His training as a teacher caused him to place a high value on the power of visual images; he wrote that documentary photographs supplied "particulars about ourselves" that helped enlighten the American people and raise the conscience of the nation. From its initial focus on Resettlement Administration projects and the problems of poor people and poor land, the work expanded. Within a few months Stryker the social scientist was describing the camera as "a device for recording American history" and encouraging his team of photographers to cover virtually all aspects of American life. The result was a

collection of images unparalleled in the history of photography. More than 75,000 captioned prints together with another 170,000 negatives were assembled by Stryker and his staff. This entire set, including the photographs taken under the auspices of the Office of War Information (OWI), is known as the FSA Collection.

World War II forced adjustments in the project; in 1942 the Historical Section was placed under the Office of War Information, with its focus narrowed to telling the story of America at war. With his staff depleted, Stryker prepared to leave the government. But before doing so, he took steps to preserve the collection. In the fall of 1943 arrangements were made to transfer this priceless heritage to the Library of Congress, headed by Stryker's friend Archibald MacLeish.

Located in 235 file drawers in the Prints and Photographs Division, the FSA photographs enjoy increasing popularity. Recent books, organized by topics such as transportation and medicine and by states including Virginia, Mississippi, Ohio, and Kentucky, have expanded public awareness of Stryker's legacy and the range and diversity of the collection.

Theodor Jung was the first FSA photographer to visit Indiana. Born in Austria in 1906, he grew up in Chicago. While working in Washington, D.C., as a draftsman for another federal agency, Jung submitted his portfolio to Stryker and was hired immediately. He came to Brown County in October 1935 to photograph the submarginal land and the rural poor of the region. His images of resettlement clients included a family of ten who had been on relief for eighteen months. Thirty years later, he recalled that his Indiana assignment called for a news shot of "the resettlement man talking with a farmer and . . . looking over the program." The result was a depiction of the official, the prospective client, his wife, and three of their children staring intently at the government papers. The photograph entitled "Soil erosion on a farm" featured worn-out, depleted agricultural

land; it became a "cookie cutter," to use Dorothea Lange's term for the several hundred FSA photographs used over and over again by newspapers and illustrated magazines.

Jung's images of Brown County bear a strong resemblance to those of Frank Hohenberger, a local artist. Both photographers produced memorable portraits of people, particularly the elderly with their lined faces exhibiting stoic calm and forbearance. The man with the mule appears to be Chris Brummett, a local character and frequent subject of Hohenberger. While Jung left the FSA in 1936, his photographs constitute an important legacy of the early years when the FSA concentrated on the lower third of the rural population.

The first person hired by Roy Stryker was Arthur Rothstein, his former student assistant, who had graduated recently from Columbia University. A native New Yorker, Rothstein's initial assignment was to set up and supervise the darkroom. Within a few months, he was in the field with a set of cameras and flash equipment. His Indiana visits featured the state's two major Resettlement Administration projects, Decatur Homesteads and Wabash Farms. Much influenced by the work of Walker Evans and Ben Shahn, two major FSA photographers who did not visit Indiana, Rothstein was a "city boy" who brought a freshness of vision to his pictures of rural life. While the project photographs are somewhat prosaic, his images of the general store in Blankenship, a village in Martin County, and his portraits of the Ross Lundy family are classics. Rothstein also shot several FSA views of Indianapolis, including scenes from the 1938 Memorial Day race. His final series included distinctive images of people at work and play taken in Knox and Parke counties in 1940, the year he left the FSA to join the staff of *Look* magazine and began a long and distinguished career as a photojournalist and editor.

In August 1936 the best-known FSA photographer of all—Dorothea Lange—made a brief visit to Indiana

and took eleven photographs of threshing near Clayton in Hendricks County. The summer heat was intense, and Lange was worried about the quality of her pictures. Stryker reassured her in October: "Your threshing negatives were most excellent." Of the eleven prints, four are included in this selection. Each affirms the skill of this woman whose photograph "Migrant Mother" is the most famous FSA image.

Lange (1895–1965) had been a professional photographer in San Francisco for many years before Stryker heeded Tugwell's call to come to Washington, D.C. On assignment with the Division of Rural Rehabilitation in California, she was transferred to Stryker's payroll at the inception of the Historical Section. While most of her work was in California and the Far West, she covered all parts of the United States with the exception of New England. She is remembered above all for her photographs of the mass emigration from the South, Midwest, and Southwest to California—the people who were called Okies—during the depression years.

It was Russell Lee (1903–1986) who took the most pictures in Indiana. Born in Ottawa, Illinois, and trained as a chemical engineer, he was managing a paint factory in 1929 when he decided to quit to study art. He soon discovered that he had greater skill with a camera than with a paintbrush. In 1936 Roy Stryker hired him to replace Carl Mydans (b. 1907), who had just resigned from the FSA staff to begin his long career with the new picture magazine *Life*.

Lee left Washington in October for what was to have been a six-week assignment in the Midwest; he did not return for nine months. His visits to Indiana included coverage of the massive flooding on the Ohio River in January and February 1937. Unlike Walker Evans, who rarely responded to Stryker's inquiries, Lee kept in regular touch with his boss by letter and telephone. From Princeton in Gibson County, he wrote, "The name 'Re-settlement' is quite well known to all these people out here." His photographs taken in northwest Indiana, including the day in the life of a hired man and the Frank Sheroan farm auction in Tippecanoe County, demonstrated his great love for detail. His unobtrusive skill with the flashbulb is apparent in the interior scenes taken in the home of Tip Estes, the hired man.

In 1942 Lee joined the Overseas Technical Unit of the Army Air Transport Command, taking aerial photographs to brief pilots. After the war he teamed up again with Stryker on the Standard Oil Company (New Jersey) Photography Project (1943—1950) before becoming a freelance photographer and part-time university faculty member. Lee has been described as "the ideal FSA photographer." He produced more photographs, spent more time in the field, and was more thoroughly committed to the work of the Historical Section than anyone else. His artistic skill is clearly demonstrated in his Indiana contributions.

When John Vachon (1915–1975) was hired in May 1936, he was an unemployed graduate student. From assistant messenger he advanced to junior file clerk and occasional photographer. Encouraged by Stryker and inspired and trained by his senior staff colleagues, Vachon became a full-time photographer in 1940. His Indiana pictures included scenes taken in Martin, Knox, and Marion counties. Vachon knew the Historical Section file, and he used this knowledge to select subjects that filled out the collection. Dorothea Lange identified his unique quality as "sensitivity" and concluded: "Sometimes it gets to the place where it hurts a little. John can do that." This sensitivity can be seen in his portrait of John W. Dillard of Washington, Indiana, and his picture of a Sunday afternoon on a front porch in Vincennes.

Vachon went into the Office of War Information when it absorbed the Historical Section. He remained in photography throughout his career, later working on the

Standard Oil project and *Look* magazine. In 1939, he described his own understanding of the role of an FSA photographer:

> To photograph any American people, phenomenon, or locality, the FSA photographer should have a thorough knowledge of his subject, both information acquired beforehand, and knowledge gained through actual contact. Then he must have *feeling*. Despite the fact that he is going to use an impersonal instrument to record what he sees, he must be intelligent enough to place what he sees in true perspective in the American scene, to feel the humor, the pity, the beauty of the situation he photographs. And lastly, the photographer must have a compelling desire to record what he sees and feels. He will want to freeze instantaneously the reality before him that it may be seen and felt by others.

The last major FSA photographer to come to Indiana was Jack Delano (b. 1914), who joined the FSA in 1940 when Arthur Rothstein left. An experienced commercial photographer, Delano traveled extensively including a lengthy assignment in Puerto Rico, an island which he made his permanent home after the war. The two series he shot in Indiana were done under the auspices of the OWI, as was the Greyhound bus trip sequence taken by OWI photographer Esther Bubley in 1943.

Delano had been a student at the Pennsylvania Academy of Fine Arts; Stryker described him as an artist who would ask, "What one picture could I take that would say Vermont?" His photographs that "say Indiana" speak to this artistic bent as he portrays a day's activity on the Indiana Harbor Belt Railroad and the military training at the Chaplains' School in Indianapolis. Delano's picture of the graduates of that school being photographed before departing for overseas duty is a fitting conclusion to this album.

During the 1930s, the population center of the United States moved slowly across Indiana. Set in the Midwest with an orientation both to the North and the South, the Hoosier State experienced a balance of industry and agriculture, of urban and rural life, which seemed to mirror the nation. Thus, the FSA photographs taken in Indiana present the external manifestations of the society at large. To view this album brings back forgotten memories of familiar people, places, and things. But even more, the images reveal the deeper ambitions, impulses, and ideals of America. This outlook was expressed by Russell Lee's wife and traveling companion, Jean, when she recalled, "There was tremendous pride and tremendous courage. We found it everywhere." Certainly the FSA photographers found that resolute spirit when they took these pictures which bring us back home again.

BACK HOME AGAIN

Indiana in the Farm Security Administration Photographs, 1935–1943

Brown and Martin Counties

THE UNGLACIATED REGION of south-central Indiana, like the foothills of the Appalachians, is beautiful country—wooded hills and ravines watered by streams that run deep in spring, may disappear in summer, and over the centuries have cut deep into the bedrock—beautiful country, but poor farmland. Brown and Martin counties are typical of this region. High land cleared for farming is soon denuded of its topsoil, and the rich bottomlands, where they are wide enough to farm, are subject to both gully-washing torrents and killing floods. A bare living is hard to wrest from these hills. In the early part of the century, more and more people from this part of Indiana had been abandoning what was clearly an unequal struggle. Voting with their feet, they moved to larger towns and cities to work. The crash of the stock market in 1929 soon reversed that trend. Massive unemployment forced many workers "back to the land." One study of 374 families who had moved to southern Indiana in the years from 1930 to 1934 reported that 78 percent of the adults had owned, worked, or grown up on farms before moving to the city. By 1932 virtually all previously abandoned farmhouses, together with buildings even less desirable, were occupied.

The Resettlement Administration was the major New Deal agency trying to help the rural poor. It advocated abandoning submarginal land and converting it to nonagricultural uses. Displaced farmers were to be relocated on productive soil, and arrangements were made so that they might eventually buy the land for themselves. At the state level, land-use planning commissions in each Indiana county supported this ap-proach. The development of state parks in the 1920s, including the very popular Brown County State Park, had anticipated this public land policy.

Both the state of Indiana and the federal government pursued the conversion of unproductive land to conservation and recreation areas. The largest of these was Hoosier National Forest, which was established in 1935 and involved almost 300,000 acres in nine counties of south-central Indiana. Federal projects transferred to the State Department of Conservation included two artificial lakes, Greenwood and Yellowwood, in Martin and Brown counties. Built in the 1930s the latter, officially known as the Bean Blossom Land Utilization Project, became part of Yellowwood State Forest, while Greenwood was included in the area that became the Crane Naval Ammunition Depot.

Theodor Jung brought his camera to southern Indiana in the fall of 1935. His pictures of Brown County are highly representative of the early themes of the FSA project. He documented the poor roads, eroded land, and inadequate living quarters. In photographs remarkable for the skill and beauty of their composition he showed people living in conditions of rural poverty.

Arthur Rothstein visited Martin County in the spring of 1938. Included in this chapter are several pictures he took of Ross Lundy and his family, who were soon to be resettled in the Wabash Farms project. The photographs by Russell Lee and John Vachon document dam construction and the negotiations between the U.S. Navy and Martin County residents for the Crane facility as the nation prepared for war.

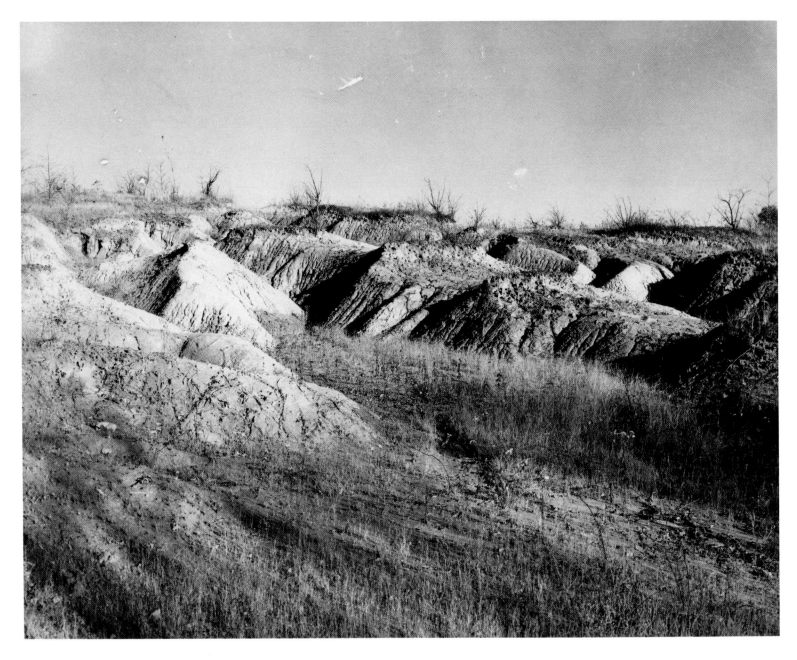

Soil erosion on a farm. Brown County. October, 1935. LC-USF 34–1005-C *Theodor Jung.*

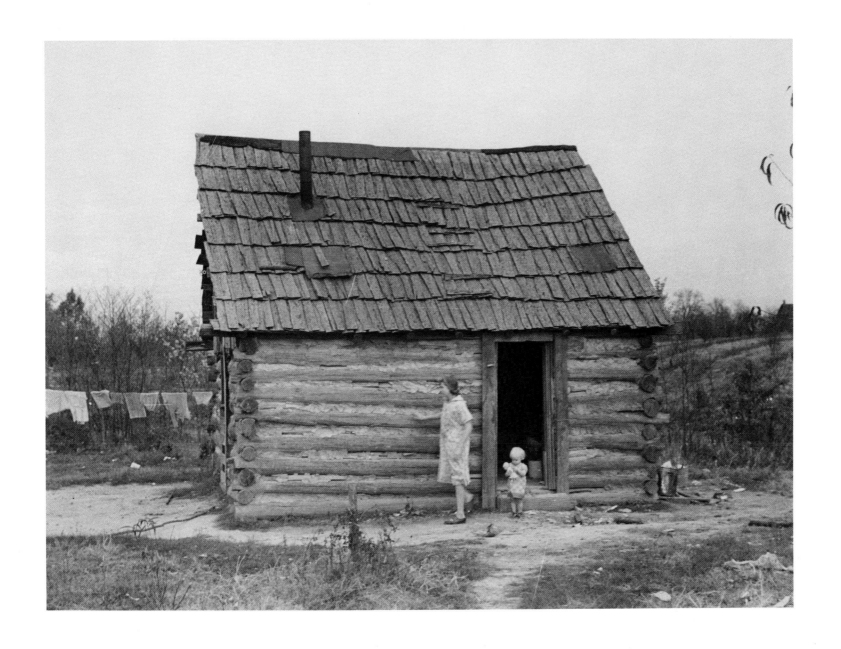

Resettlement phase of a U.S. Resettlement Administration agricultural development project. Home of a family of ten that has been on relief for eighteen months. Brown County. October, 1935. LC-USF 33–4035-M4 *Theodor Jung*.

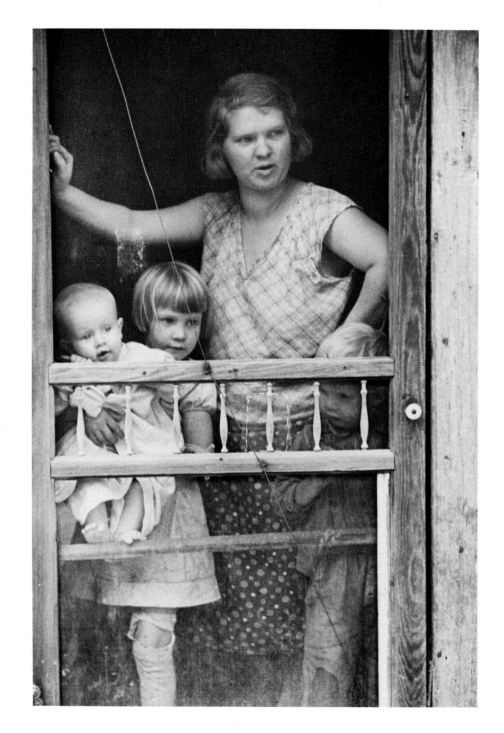

Family of a prospective client.
Brown County. October, 1935.
LC-USF 33–4038-M1 *Theodor Jung.*

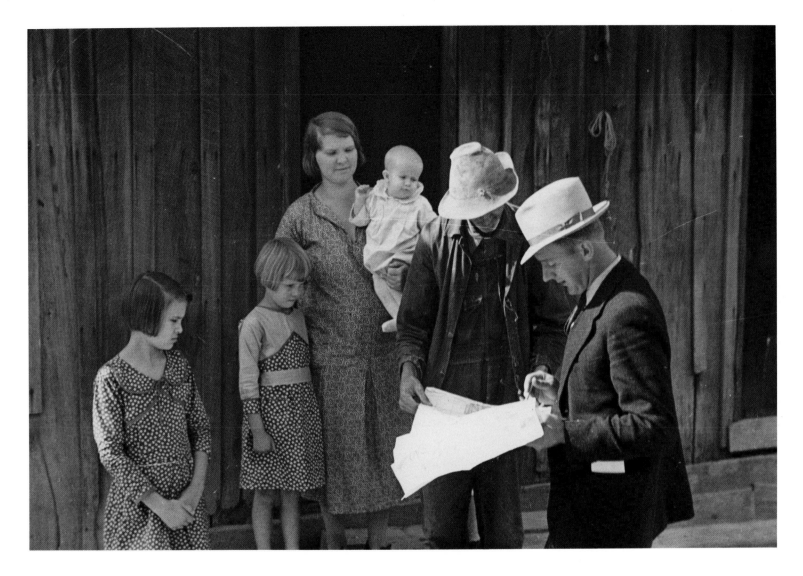

Client talking things over with the government representative. Brown County. October, 1935.
LC-USF 33–4041-M1 *Theodor Jung.*

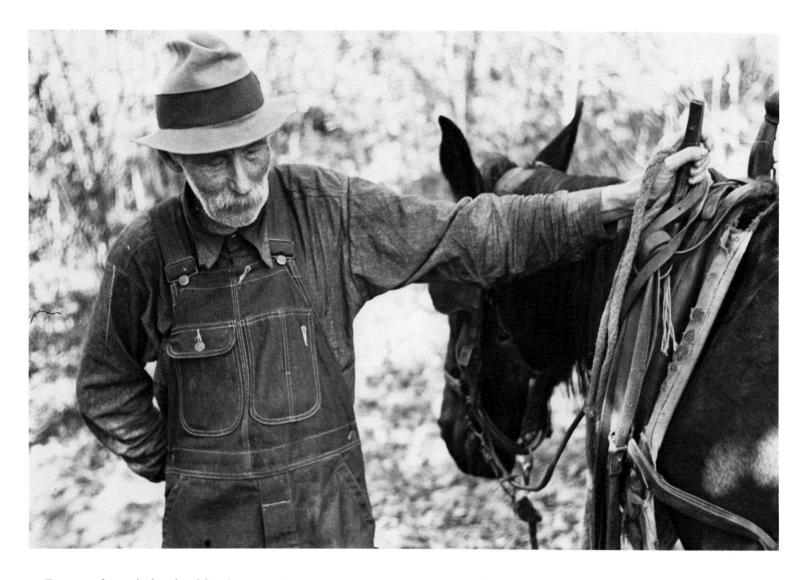

Farmer whose timber land has been optioned by the government. Brown County. October, 1935.
LC-USF 33–4029-M5 *Theodor Jung.*

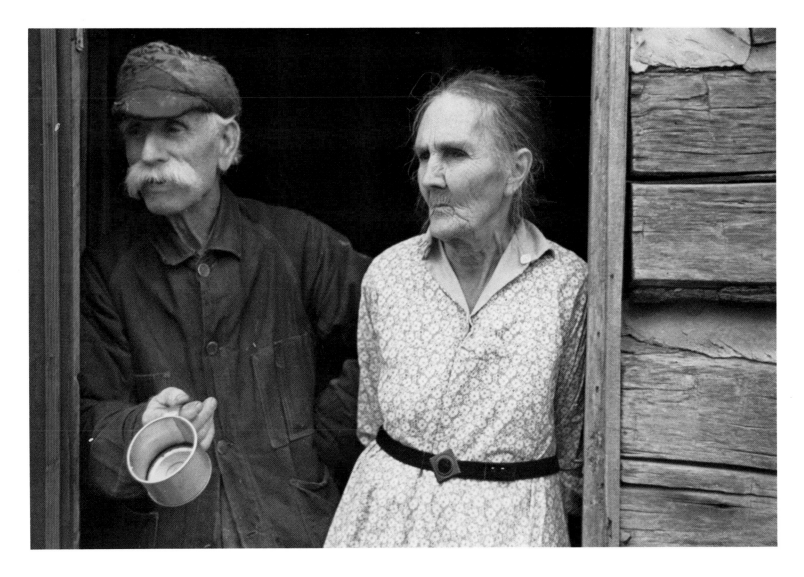

Prospective clients whose property has been purchased by the government. Brown County. October, 1935.
LC-USF 33–4051-M4 *Theodor Jung.*

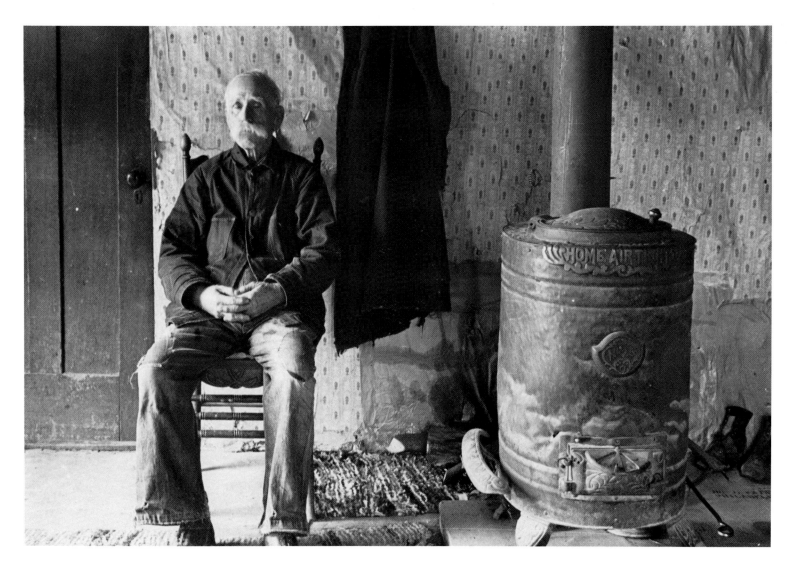

Client whose property has been optioned by the government. Client will be moved to new, better land when property has been purchased. Brown County. October, 1935. LC-USF 33–4047-M1 *Theodor Jung.*

Advertisement in a hardware store. Nashville. October, 1935. LC-USF 33–4031-M5 *Theodor Jung*.

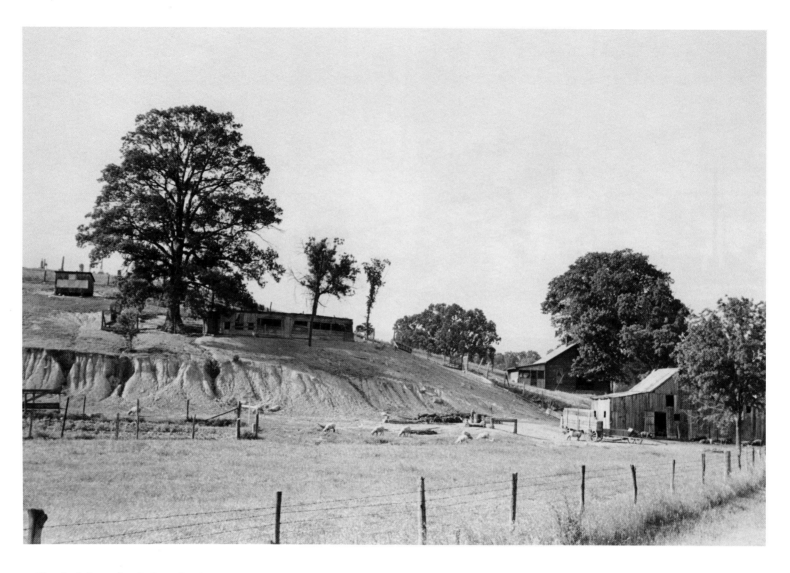

Eroded farm land. Martin County. May, 1938. LC-USF 33–2726-M3 *Arthur Rothstein.*

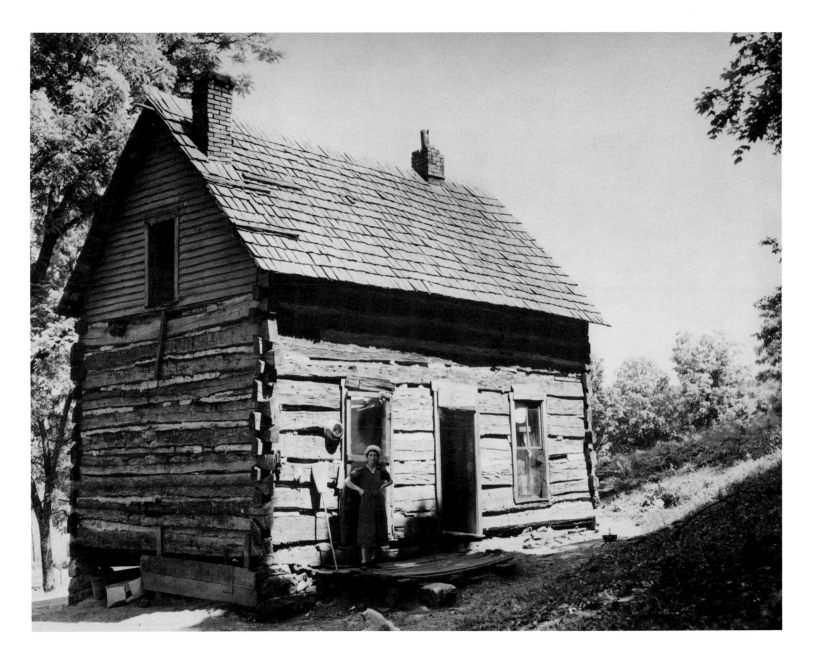

The home of Ross Lundy, Martin County. June, 1938. LC-USF 34–26462-D *Arthur Rothstein.*

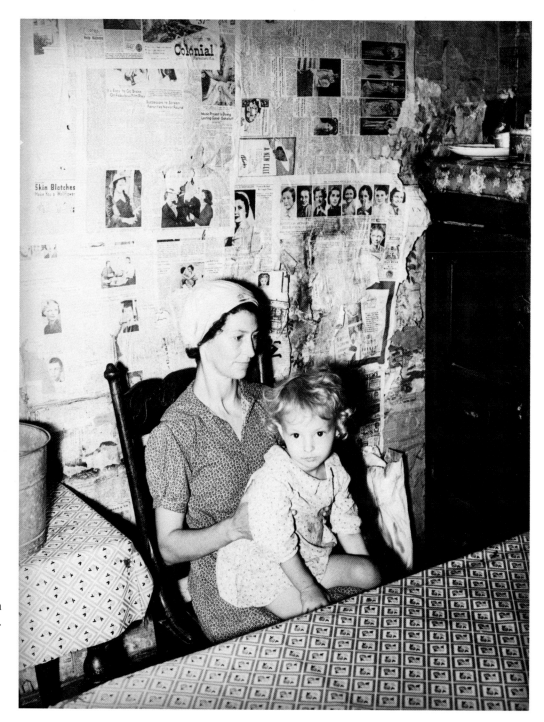

Mrs. Lundy and her daughter in their log cabin. Martin County. June, 1938.
LC-USF 34–26468-D
Arthur Rothstein.

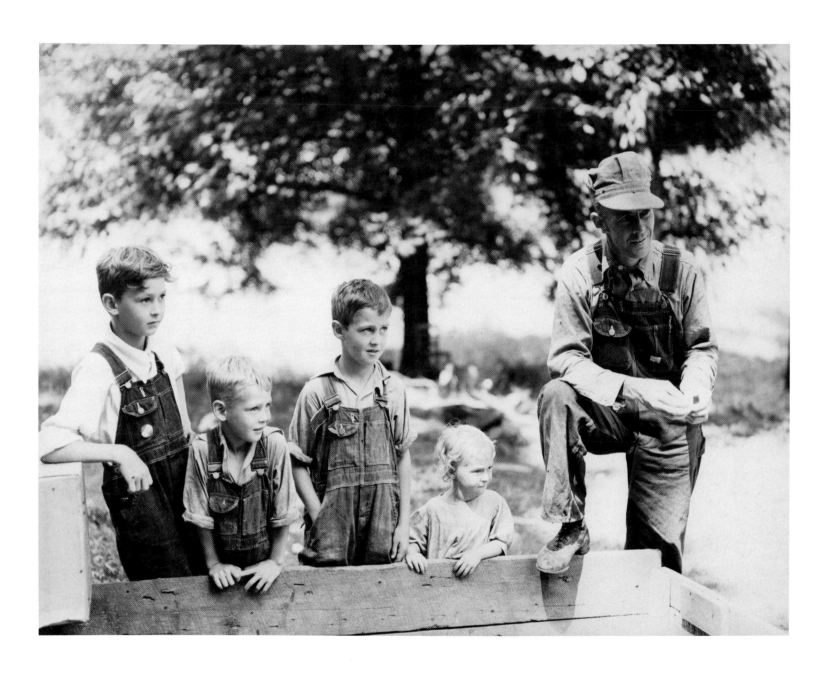

Ross Lundy and his children. Family will be resettled at Wabash Farms, a U.S. Resettlement Administration project, in southwestern Indiana. June, 1938. LC-USF 34–26460-D *Arthur Rothstein.*

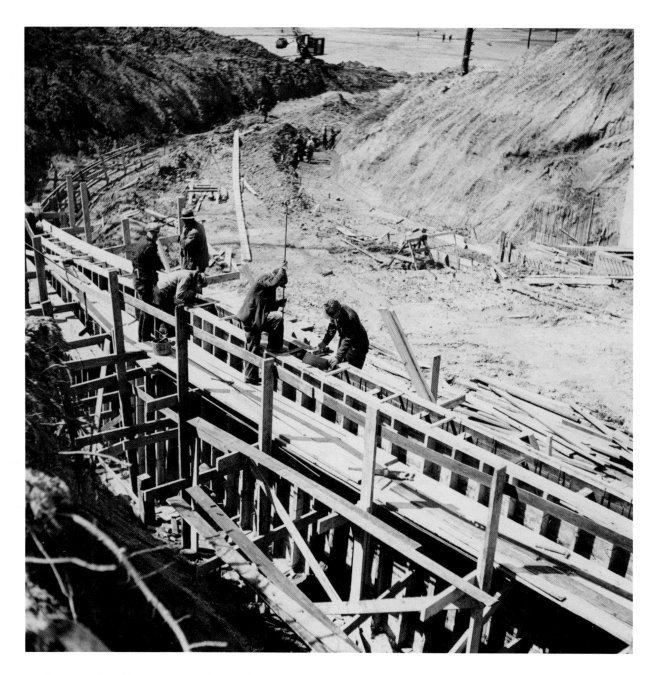

Constructing forms for pouring concrete. Martin County development projects of the
U.S. Resettlement Administration in Indiana. April, 1937. LC-USF 34–10799-E *Russell Lee.*

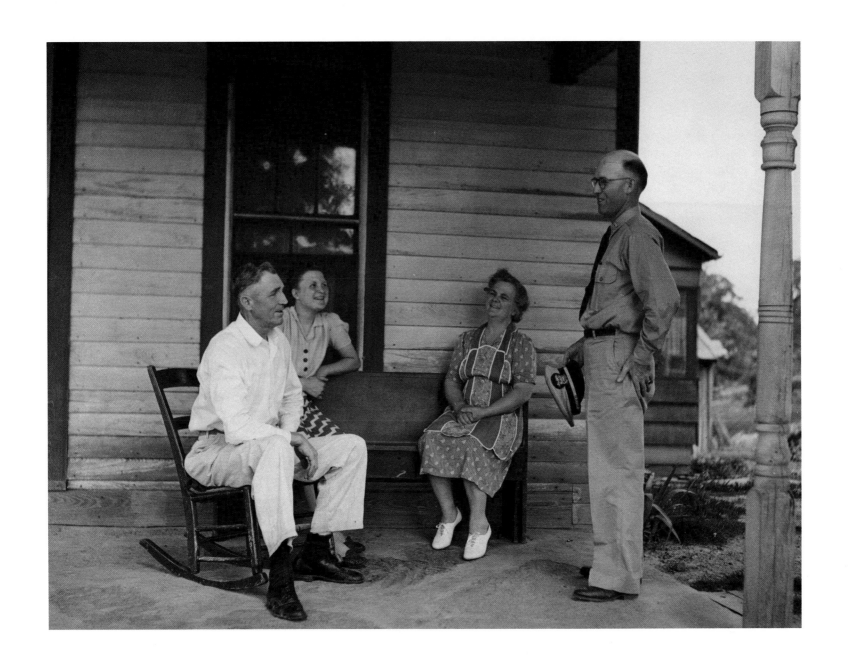

Lieutenant Sedgewick of the U.S. Navy, talking with Luther Corbin and his family. Martin County. June, 1941.
LC-USF 34–62957-D *John Vachon.*

Resettlement Projects

THERE WERE TWO major resettlement projects in Indiana: Decatur Homesteads in the northeast and Wabash Farms in the southwest. Decatur Homesteads, in Adams County, was one of the earliest federal efforts to provide adequate housing for workers in small industrial cities. M. L. Wilson, the director of the Federal Subsistence Homesteads Corporation (FSHC), described Decatur Homesteads as "a test and a demonstration of the opportunities of workers in small cities to increase their standard of living by reducing their dependence on pay envelopes to achieve a satisfactory livelihood." Authorized in December 1933, it followed the first FSHC project, Arthurdale, in West Virginia, which had been publicized because of Eleanor Roosevelt's enthusiastic support.

Decatur Homesteads was intended to keep urban residents off relief rolls. The federal government provided the funds for the project, the General Electric Company employed many of the workers, and the city of Decatur furnished the water lines and the electrical hook-ups to the municipal power plant. On the eighty-acre site there were forty-eight five-room houses, each with an average of 1.3 acres of land. Seven different styles of homes were built from pre-assembled sections at prices ranging from $2,335 to $2,350. Each dwelling faced the fifteen-acre park; occupants were selected who would establish gardens. By 1935 all forty-eight houses had been completed and were occupied; residents paid $19 a month to the Homestead Association Corporation to purchase their homes. After World War II, the homesteaders refinanced their homes on an individual basis and in 1947 the corporation was dissolved.

The Homesteads project, described as a "showpiece of civic pride and community action," continues to be one of the most prestigious residential areas in Decatur. All but one of the homes have been enlarged and five of the original residents still live there. The homeowners have an association that meets annually and they celebrate holidays as a community. As the FSA photographs taken by Paul Carter, Carl Mydans, and Arthur Rothstein show, Decatur Homesteads was a "noble experiment," the result of public-private cooperation and a realistic vision of the future.

Wabash Farms, on the other hand, must be judged a failure. The goals of that project were more ambitious: Some of the destitute and low-income rural families who had been displaced by government purchases of sub-marginal land in Brown and Martin counties were resettled on individual family farms; a housing project for industrially employed families was built; and a cooperative farm of 2,770 acres involving more than twenty resettled families was set up. Scenic Hill, the subsistence-farm project on the outskirts of Loogootee, consisted of a barn and fifteen houses. Antipathy to government intervention ran high in Martin County; Scenic Hill was dubbed "Hitlerville" by many. The large cooperative farm, ten miles south of Vincennes in Knox County, had a large L-shaped barn, housing for more than twenty families, and several outbuildings. It was named Deshee Farms for a creek running through this area of bottom-land between the White and Wabash rivers. Like Scenic Hill, Deshee Farms was a target for rancor; it was often referred to as "Little Russia."

Families moved to Deshee Farms in 1938; unlike

Decatur Homesteads and Scenic Hill, it was a full-scale farm operation with modern equipment and specific work assignments. The residents were paid on an hourly basis, received free rent from the cooperative, and were eligible to share in both the profits and the losses. The chief source of income was the dairy herd of more than a hundred cows. The cooperative also raised chickens and hogs for market as well as cash crops—melons, tomatoes, wheat, and corn. Every family had its own garden plot. Workers were assigned such specialized tasks as managing the poultry unit or the dairy herd. One unexpected result was that several farmers went on to management positions on large commercial farms; however, most members eventually became dissatisfied, and turnover was high. A major flood in 1943 was "a terrible blow to the cooperative"; it coincided with the federal government's decision to abandon the nearly two hundred resettlement projects across the nation. Deshee Farms was sold in 1944 through public auction to Charles H. Schenk whose family still operates the property under the name Schenk Farms.

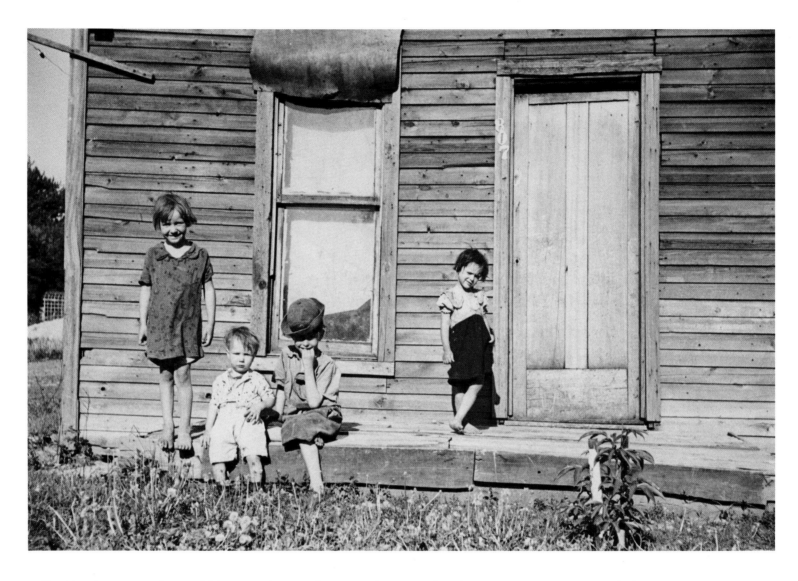

Housing in an area from which many Decatur homesteaders are taken for a U.S. Resettlement Administration project near Decatur. May, 1936. LC-USF 33–620-M2 *Carl Mydans.*

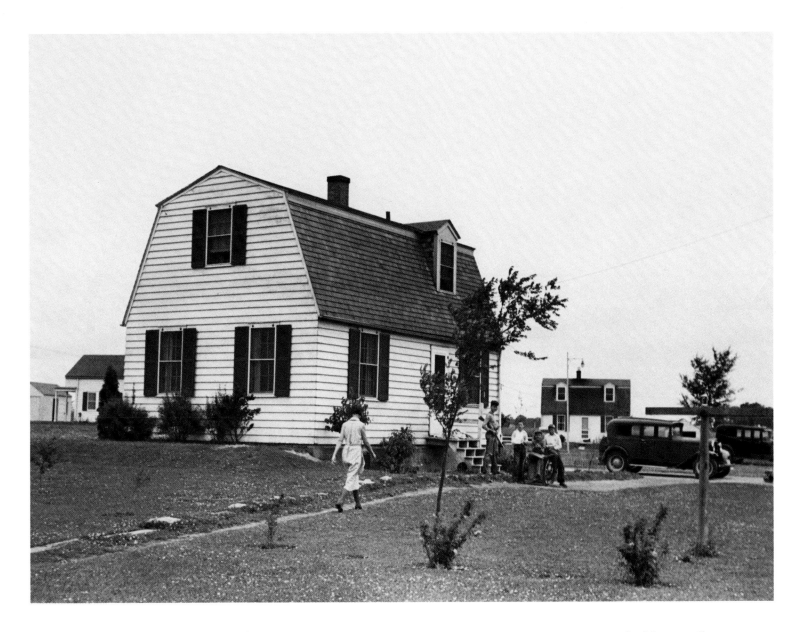

A rural rehabilitation project of the U.S. Resettlement Administration. House, Decatur Homesteads. May, 1938.
LC-USF 33–2723-M2 *Arthur Rothstein.*

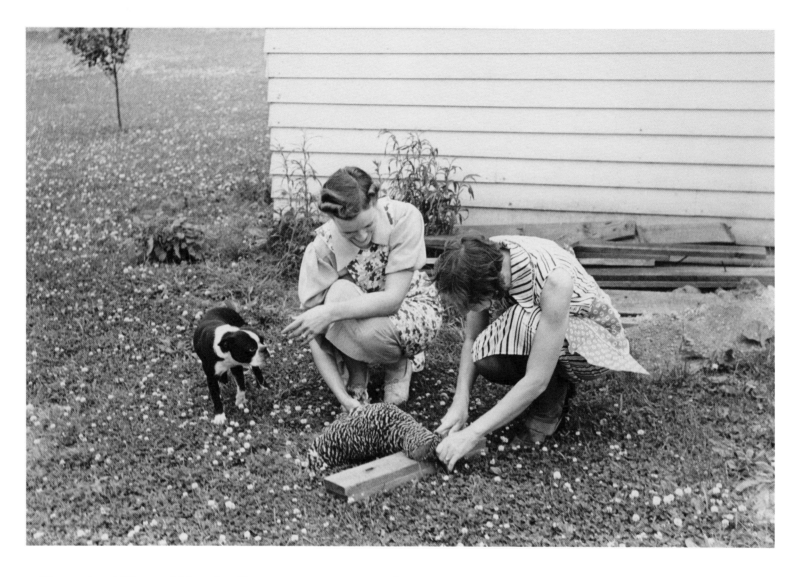

Housewives killing a chicken for dinner. Decatur Homesteads. May, 1938. LC-USF 33–2723-M3 *Arthur Rothstein.*

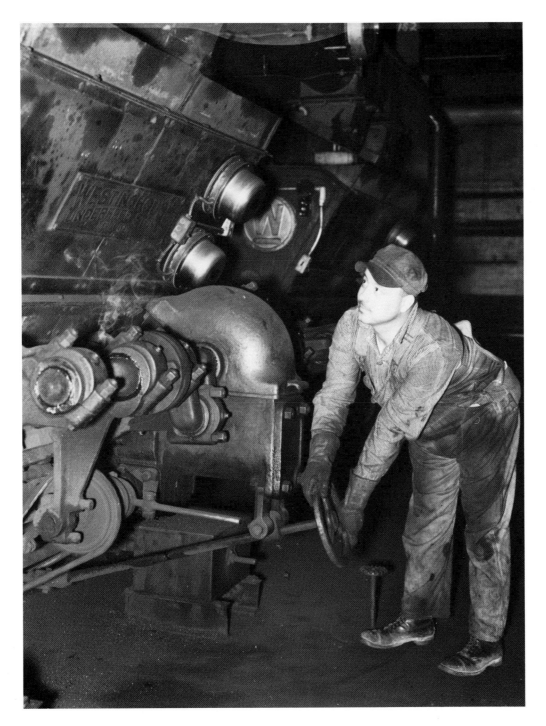

Walter Bollinger, who works at the
municipal light plant and lives at
the Homesteads. June, 1938.
LC-USF 34–26411-D
Arthur Rothstein.

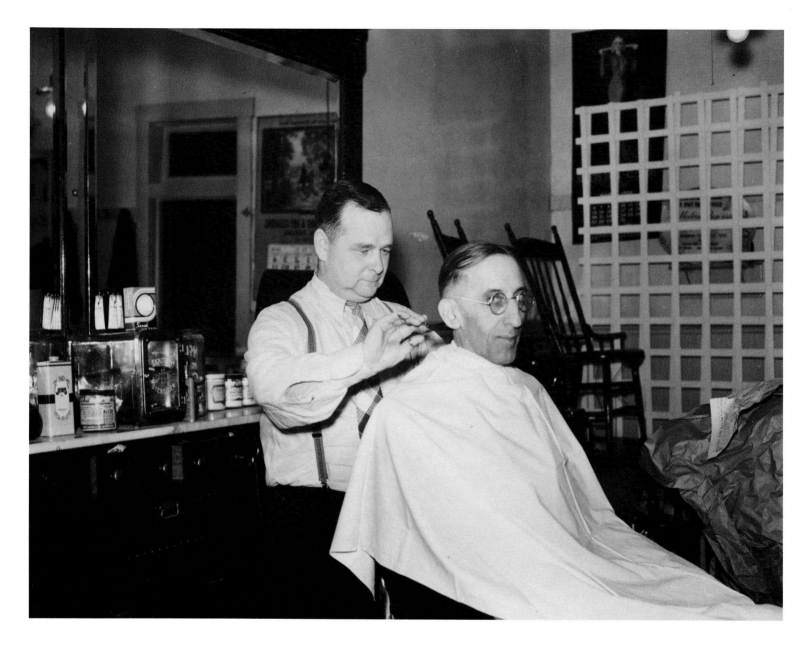

Morris Pingry, a barber, who lives at the Homesteads. June, 1938. LC-USF 34–26436-D *Arthur Rothstein.*

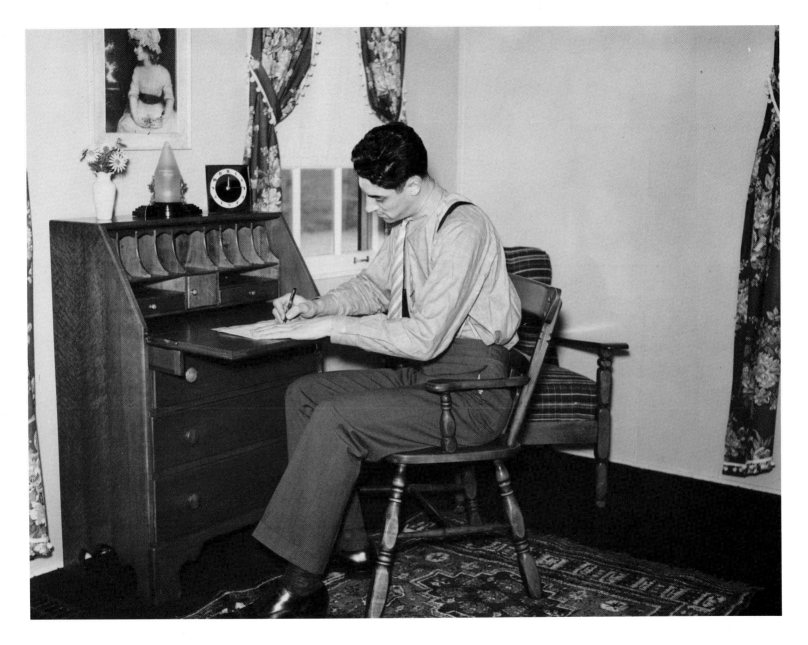

John Kinder, a hotel clerk, in his home. Decatur Homesteads. June, 1938. LC-USF 34–26413-D *Arthur Rothstein.*

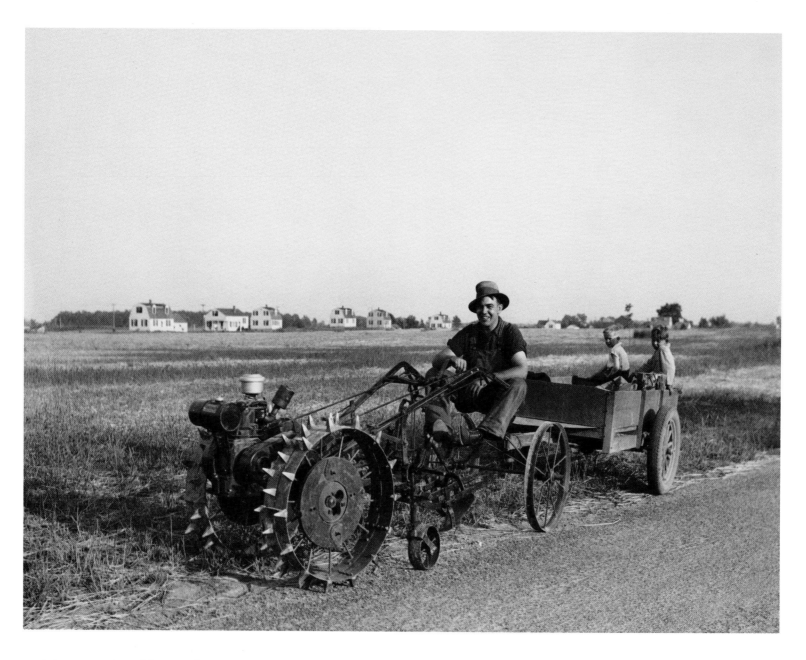

A homesteader with a garden tractor. Decatur Homesteads. May, 1936. LC-USF 34–6422-D *Carl Mydans*.

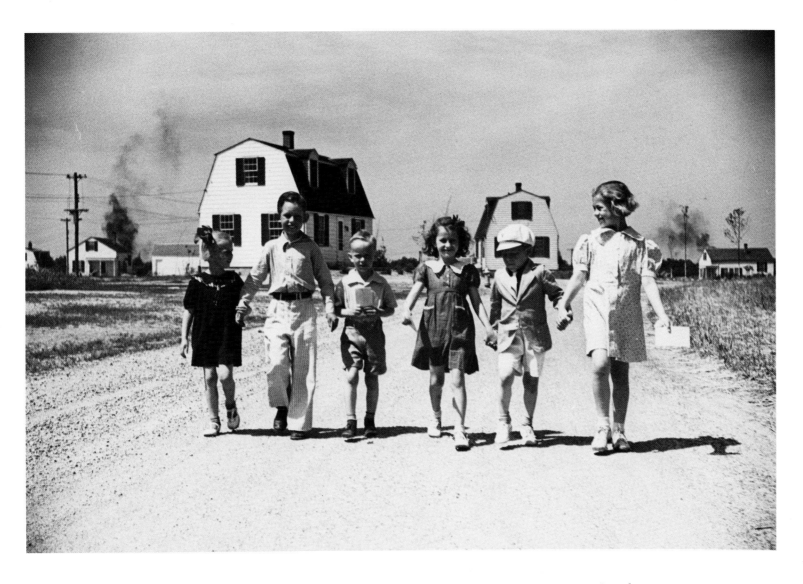

Children coming home from school. Decatur Homesteads. May, 1936. LC-USF 33–618-M3 *Carl Mydans.*

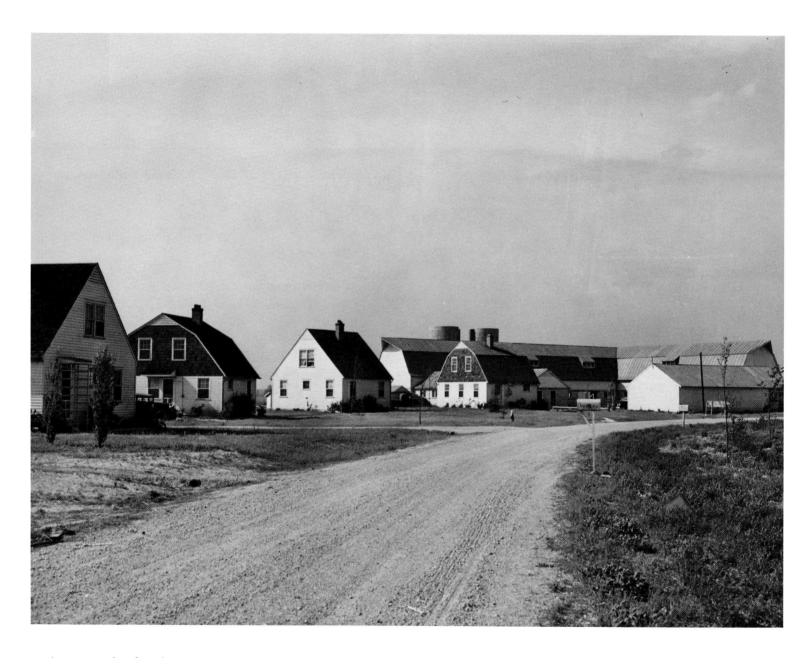

A cooperative farming enterprise of about fifty families: Wabash Farms, a U.S. Resettlement Administration project in southwestern Indiana. May, 1940. LC-USF 34–60971-D *John Vachon.*

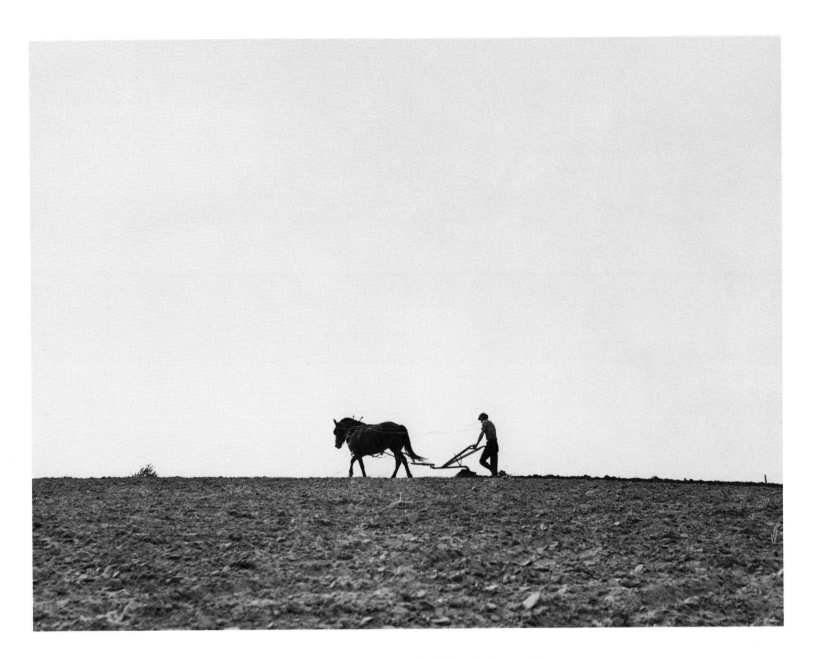

Plowing the ground for cantaloupe planting on the Deshee unit, Wabash Farms. May, 1940.
LC-USF 34–60972-D *John Vachon.*

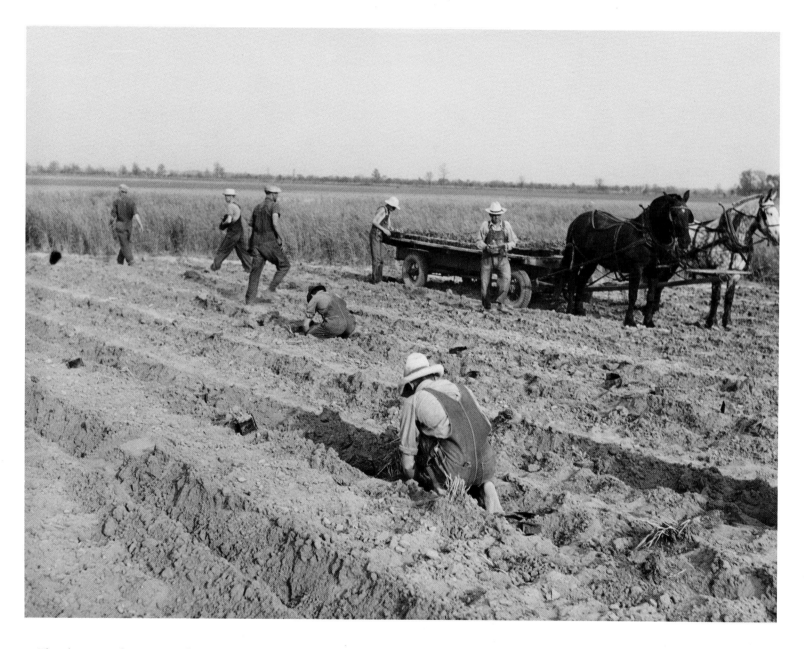

Planting cantaloupes on the Deshee unit, Wabash Farms. May, 1940. LC-USF 34–60999-D *John Vachon.*

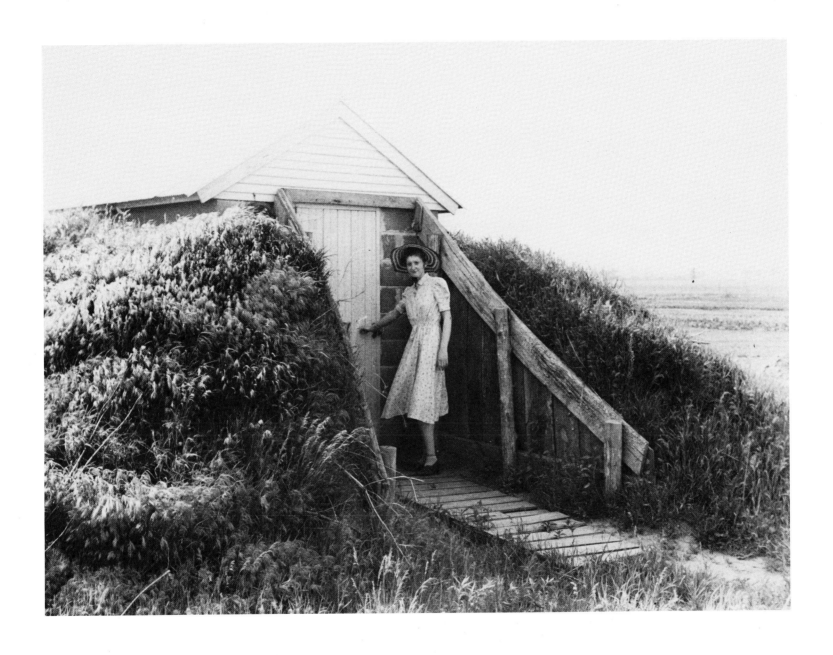

Food storage cellar on the Deshee unit, Wabash Farms. May, 1940. LC-USF 33–1873-M1 *John Vachon.*

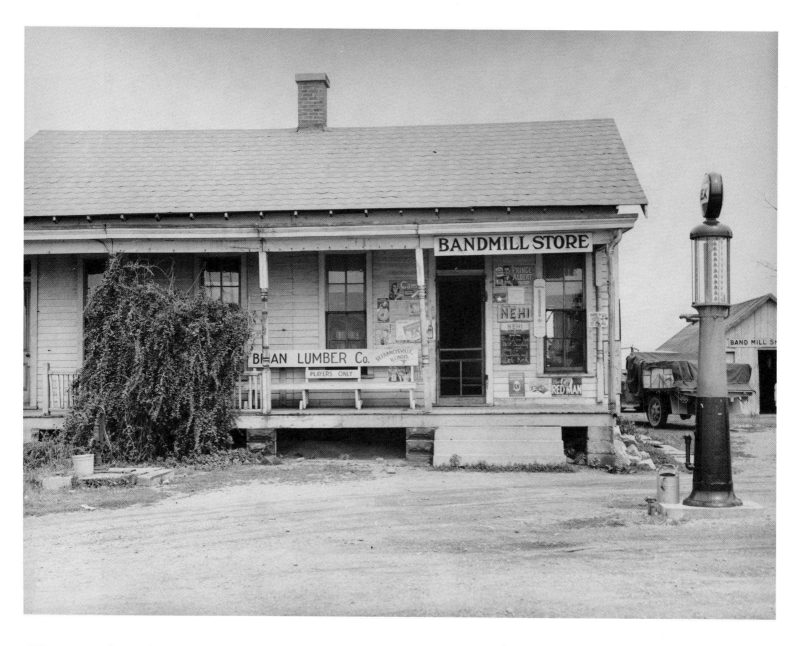

The cooperative makes use of the existing stores in the area. Wabash Farms. June, 1938. LC-USF 34–26396-D *Arthur Rothstein.*

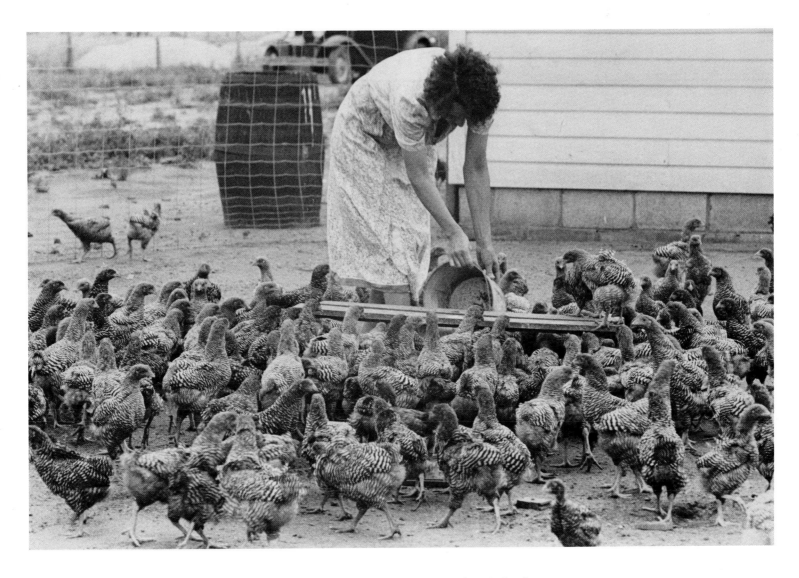

Feeding chickens. Wabash Farms. May, 1938. LC-USF 33–2770-M5 *Arthur Rothstein.*

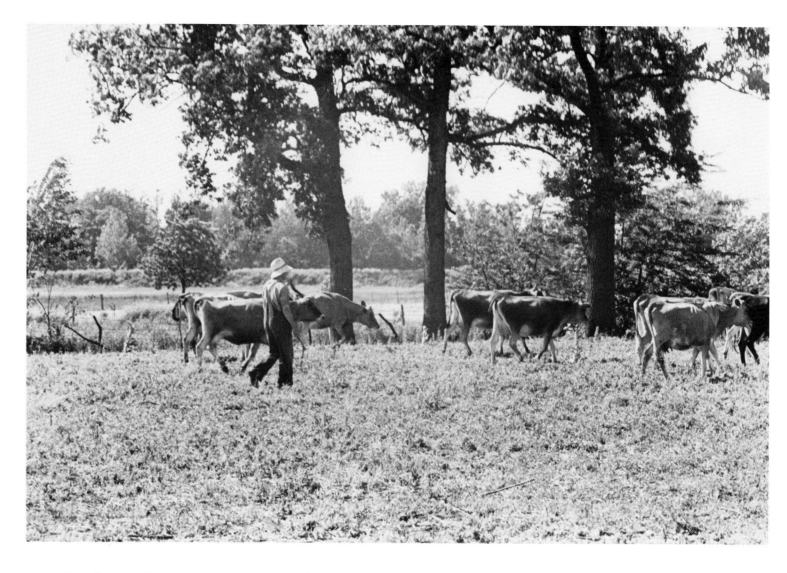

Driving the cows from pasture. Wabash Farms. May, 1938. LC-USF 33–2777-M1 *Arthur Rothstein.*

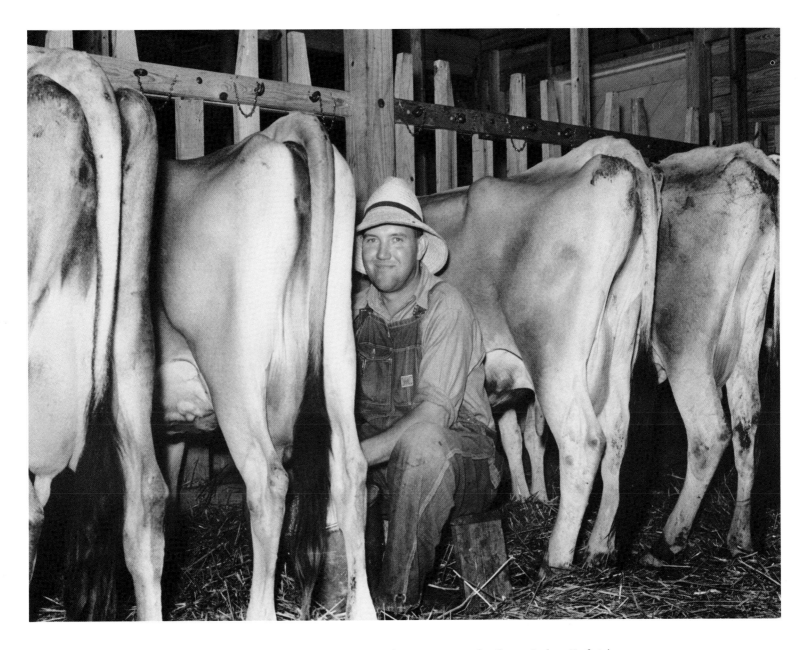

Milking in a project dairy barn. Wabash Farms. June, 1938. LC-USF 34–26378-D *Arthur Rothstein.*

Mrs. Lester Barnes, resettled farmer's wife. Wabash Farms. May, 1938.
LC-USF 33–2769-M2 *Arthur Rothstein.*

Tractor and horses on the Deshee unit coming in from the field at the end of the day. Wabash Farms. May, 1940. LC-USF 34–60967-D *John Vachon.*

The Great Flood of 1937

THE GREAT FLOOD OF 1937 was a disaster of unprecedented magnitude. It broke all previous flood records in the lower Ohio Valley. Never before had so much land been under water for so long. The amount of damage in the cities, towns, and countryside was enormous. In late December 1936 heavy rains began to fall throughout the region; by the end of January, rainfall in excess of nineteen inches had been recorded in many areas (less than three inches was normal for the month). "Rare meteorological conditions had created this calamitous inundation of almost Biblical proportions," said a spokesman for the U.S. Army Corps of Engineers.

Indiana was very hard hit. Ninety-five percent of Jeffersonville, Clarksville, and Utica were under water. The town of Leavenworth was utterly destroyed (it was later rebuilt on higher ground). At Evansville, the Ohio reached its flood stage of thirty-five feet on January 10, crested above fifty-three feet on January 31, and did not recede to flood-stage level until February 19, some forty days later.

The flood was reported in newspapers and magazines, in movie newsreels, and over radio stations across the nation. The Resettlement Administration, the WPA, the American Red Cross, the Coast Guard, and the Army all worked to evacuate victims, prevent looting, provide food and shelter, and transport supplies. Tent cities sprang up at Jeffersonville and Evansville to care for the refugees. When they were at last able to return to their homes, the evacuees were faced with ruined streets and roads, cracked foundations, ceilings, and walls, floors ankle-deep in mud, and furniture turned to trash. The thing that "hurt the worst," as one flood victim recalled, was losing books, pictures, papers, and mementoes. "You could buy more furniture, but you couldn't buy those. They were gone forever."

The photographer Russell Lee, who had just been appointed to the regular staff of the Historical Section, was visiting relatives in northern Illinois at the time of the flood. Roy Stryker wrote to him, "Better watch out, or you'll get caught in the flood raging in that part of the country. Incidentally, if you get a chance to take any pictures . . . , be sure to get them. . . ."

Lee had been thinking along the same lines. While this letter was in the mail, he wrote, "Have been reading a lot [about] the floods in southern Indiana and Illinois. Do you want any pictures of this subject?" Stryker's reply on January 23 advised against duplicating the work of the news people and urged Lee to concentrate instead on the "devastation to farm buildings, houses, land, and so on." Lee traveled to southwestern Indiana; there, in Posey County, at the confluence of the Wabash and the Ohio, he produced a memorable series of photographs.

In the desolate mudflats Lee found symbols to convey the meaning of the disaster. His images included drowned livestock, wrecked buildings, and eroded fields. The most famous picture was of a ruined pump organ standing upright in an open field. Edward Steichen, the dean of American photography, selected this image for the 1938 annual issue of *U.S. Camera*. Steichen wrote: "This photograph makes any cockeyed Dada picture seem like a blooming Christmas card in comparison to this grinning gargoyle." Describing this scene to me in April 1986, a few months before his death, Russell Lee said, "Hell, it was just there. I sure didn't move it!"

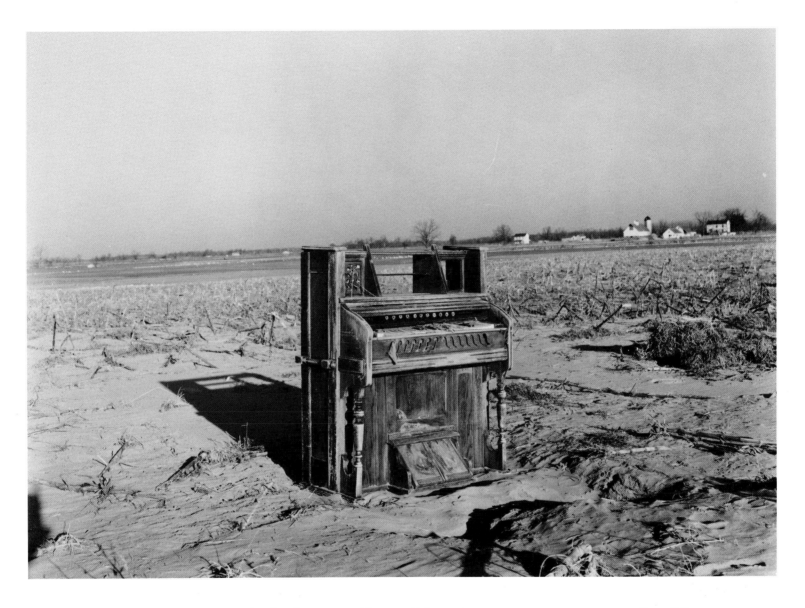

An organ deposited on a farm by the flood near Mt. Vernon. February, 1937. LC-USF 341–10435-B *Russell Lee.*

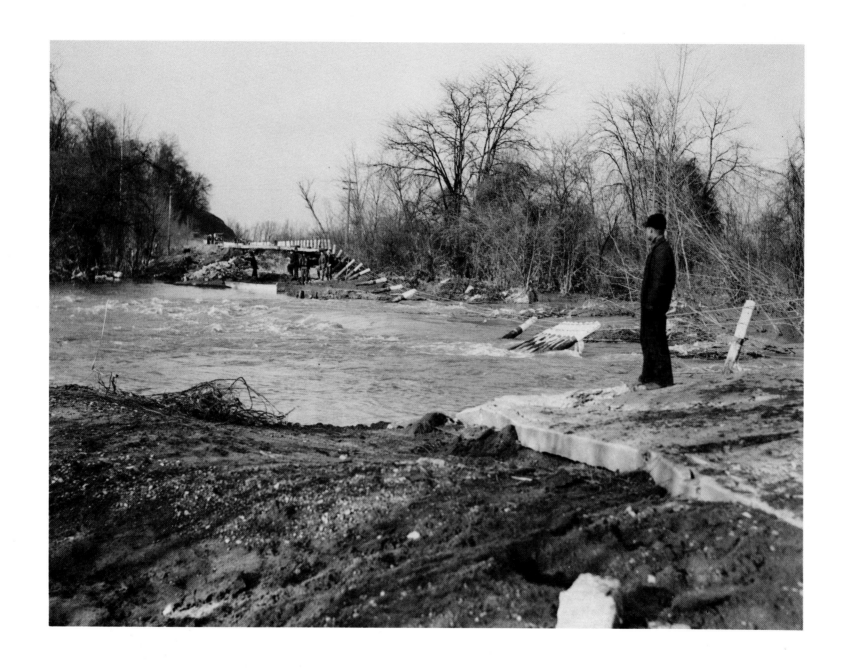

State highway flooded by the White River near Hazelton. February, 1937. LC-USF 34–10474-D *Russell Lee.*

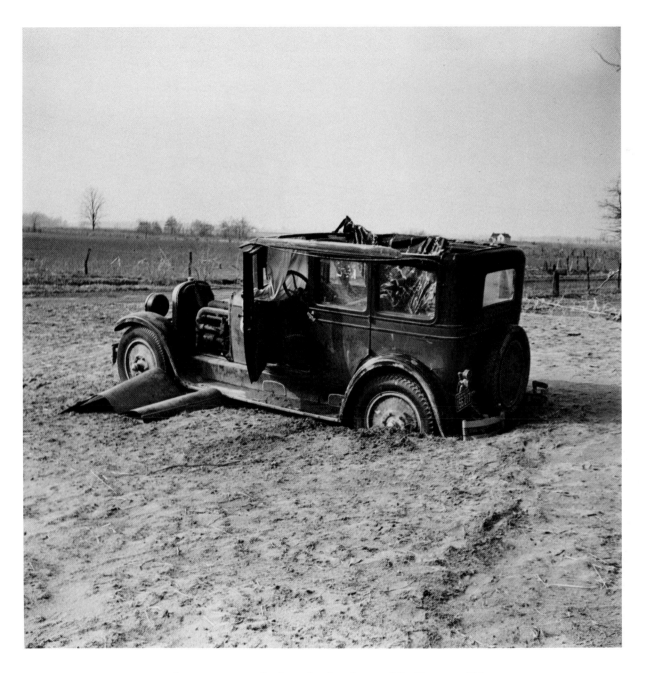

An automobile on Mackey Ferry Road after the flood near Mt. Vernon. February, 1937.
LC-USF 34–10327-E *Russell Lee.*

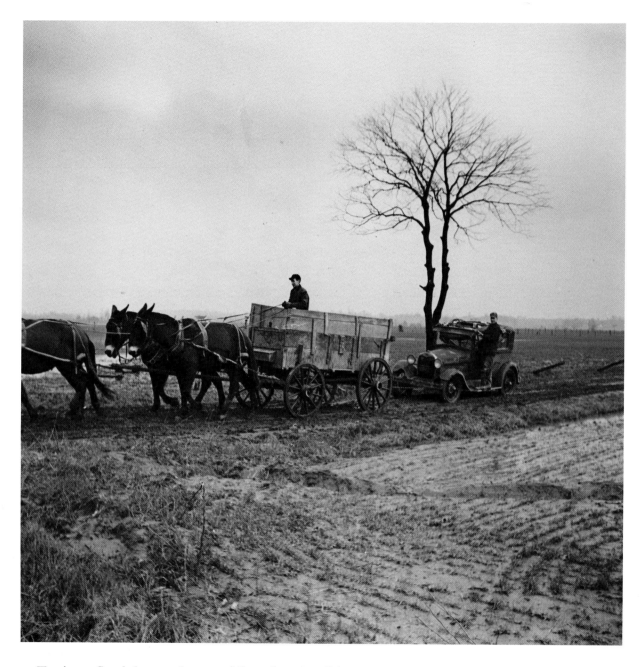

Towing a flood-damaged automobile to be reconditioned. Point Township, Posey County. February, 1937. LC-USF 34–10328-E *Russell Lee*.

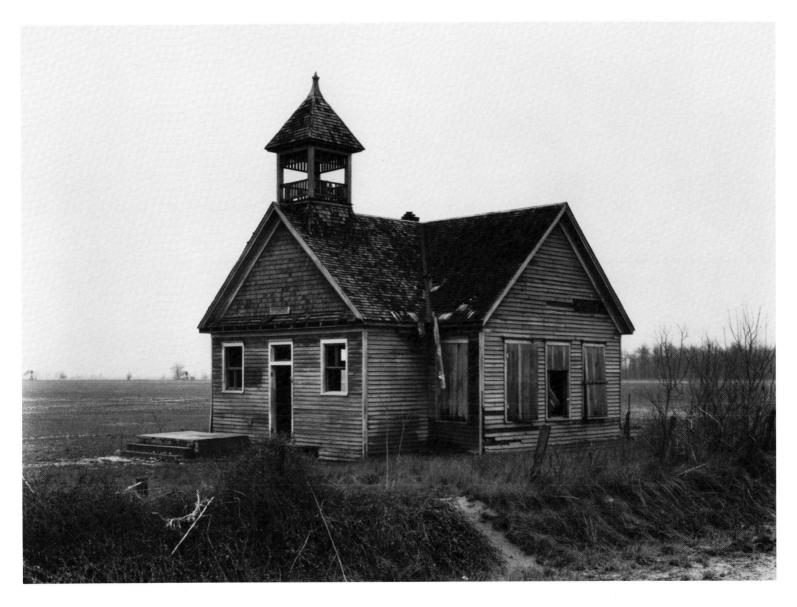

County schoolhouse after the flood. Posey County. February, 1937. LC-USF 341–10359-B *Russell Lee.*

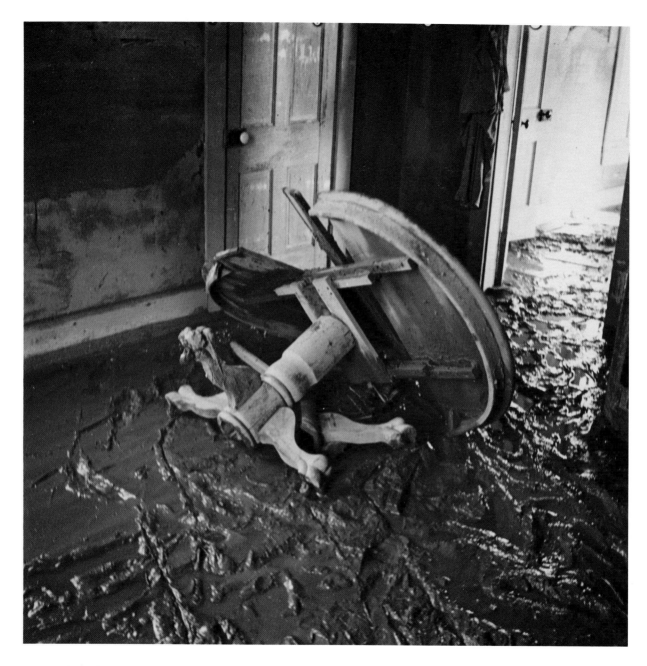

Interior of a farmhouse after the flood. Posey County. February, 1937.
LC-USF 34–10321-E *Russell Lee.*

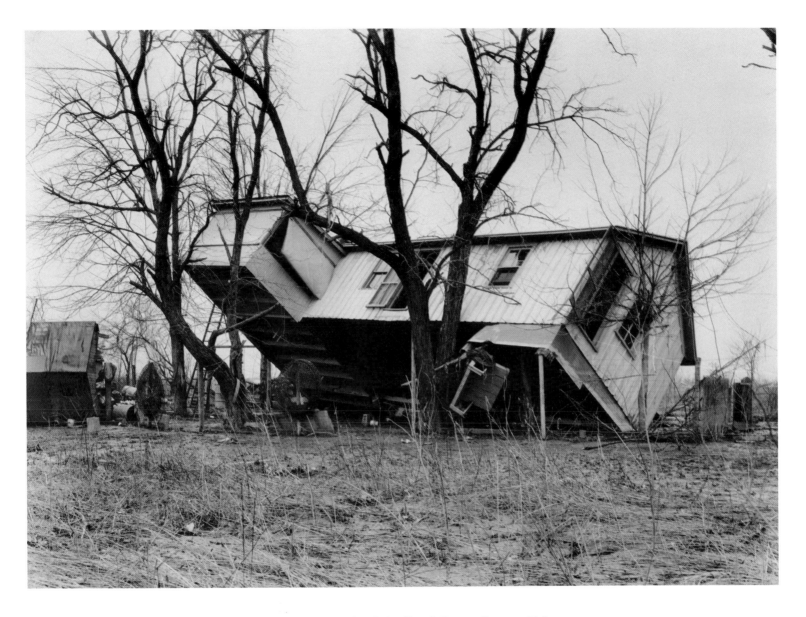

Upturned farmhouse resting against a tree as a result of the flood. Posey County. February, 1937.
LC-USF 341–10338-B *Russell Lee.*

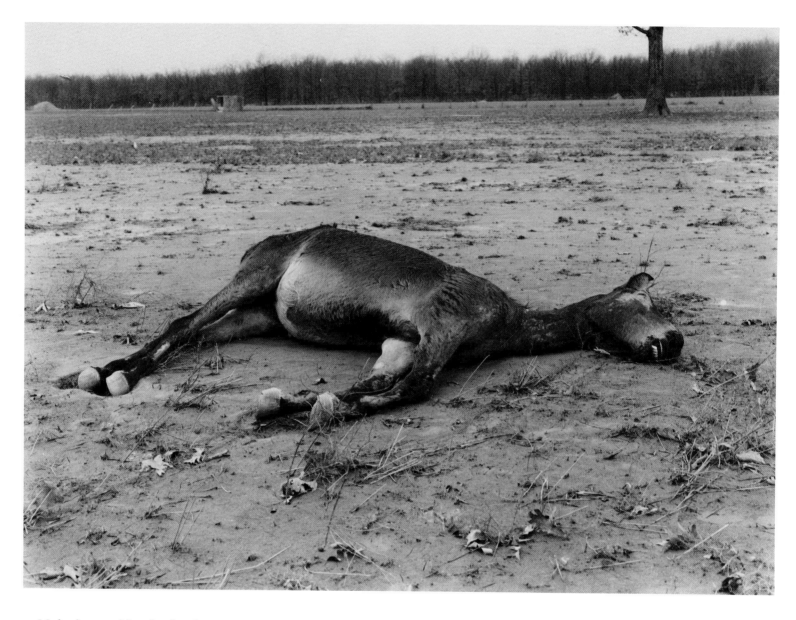

Mule drowned by the flood. Posey County. February, 1937. LC-USF 341–10357-B *Russell Lee.*

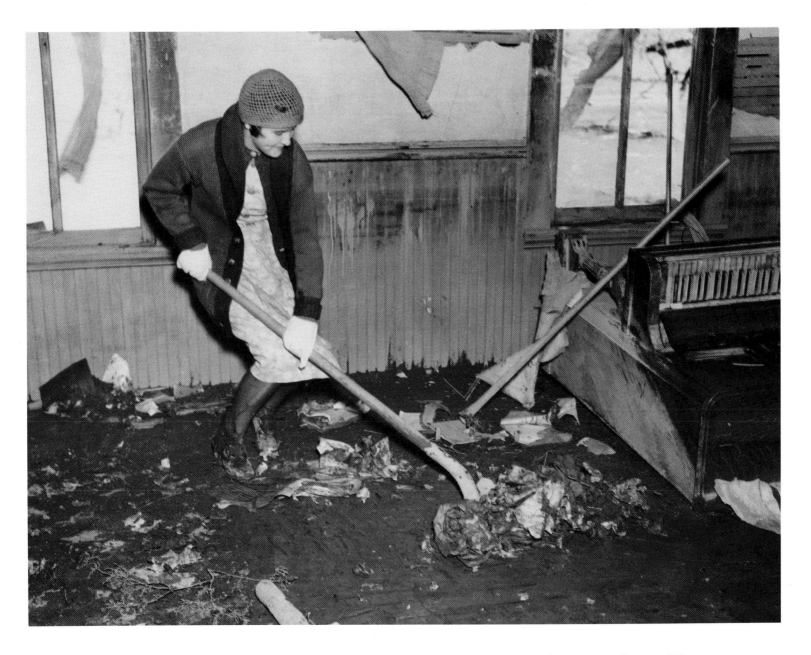

A woman shoveling silt and debris from a flooded farm house. Note the overturned piano. Posey County. February, 1937. LC-USF 34–10312-D *Russell Lee*.

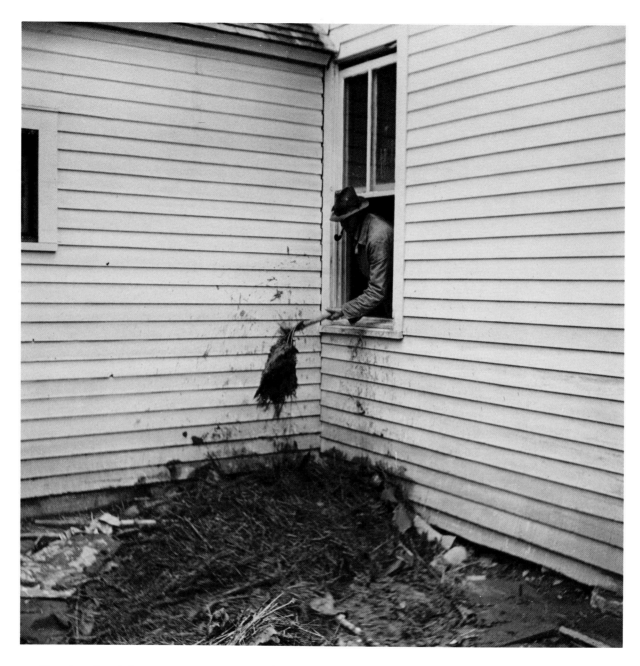

Cleaning flood debris out of a farm house. Posey County. February, 1937.
LC-USF 34–10315-E *Russell Lee.*

People and Places

TO HELP HIS PHOTOGRAPHERS carry out their assignments, Roy Stryker prepared lists of possible subjects called "shooting scripts." The most famous list developed from a long conversation with his old friend and former colleague at Columbia University, Robert Lynd, in the spring of 1936. Earlier Lynd had collaborated with his wife, Helen, to write the now classic *Middletown: A Study in American Culture*, based on their pioneering study of Muncie, Indiana. Intrigued by the selection of FSA photographs Stryker brought with him, Lynd encouraged the Historical Section administrator to focus attention on small-town America.

In the scripts that resulted from this discussion, Stryker described the small town as "the crossroads where the land meets the city, where the farm meets commerce and industry. It is the contact point where men of the land keep in touch with a civilization based on mass-produced, city-made gadgets, machines, canned movies and canned beef." His shooting scripts targeted objects ranging from polished shoes, signs, and buildings to "the difference in the men's world and the women's world," "contented looking old couples," and "how . . . people look"; he made the small town a "perennial rather than a special assignment" for the FSA photographers.

Many of the best images taken in Indiana reflect Stryker's emphasis on the small town and its relationships to the surrounding countryside. While the two Theodor Jung photographs of the Rustic Inn in Nashville and the noon-day siesta in Helmsburg predated the 1936 script, main streets, signs, and diners were common features in the contributions of John Vachon and Arthur Rothstein. In Blankenship, a village in Martin County four miles east of Burns City, Rothstein recorded daily life centering around the general store with its well-stocked shelves and its friendly atmosphere. Three years after these photographs were taken, Blankenship was gone: it became part of the Crane Naval Ammunition Depot.

The illustrations from Knox, Parke, and Daviess counties portray varied aspects of daily life. There are few FSA photographs of big cities; often these were made on assignments for other federal agencies such as the Public Health Service. Two Indianapolis scenes depict the Woolworth store on Washington near Meridian and the theater on Monument Circle. These images suggest a crowded, austere, rather anonymous lifestyle in marked contrast to the relaxed, neighborly pace of the small-town scenes.

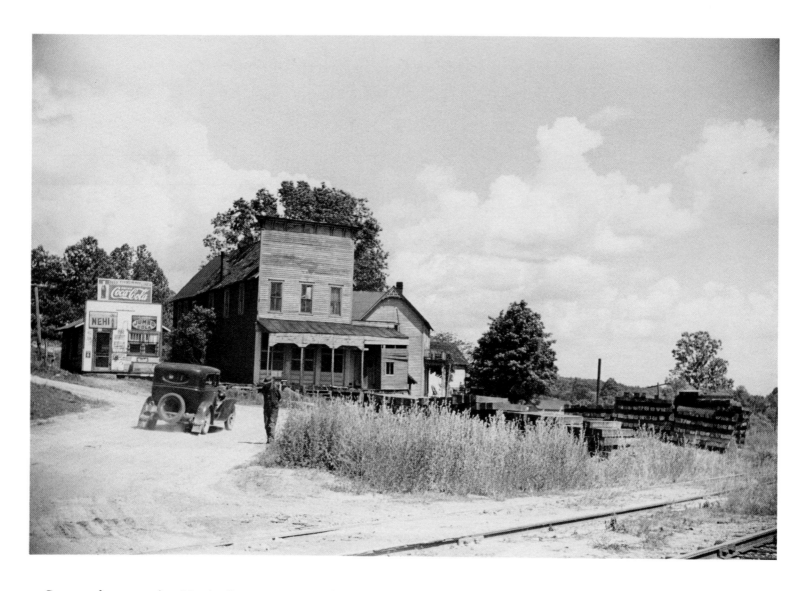

Crossroad community. Martin County. May, 1938.
LC-USF 33–2753-M3 *Arthur Rothstein.*

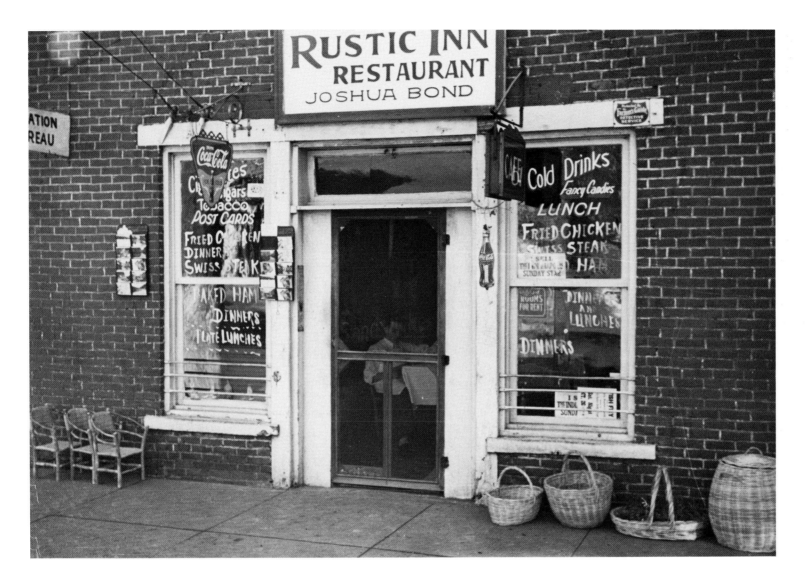

A restaurant and shop. Nashville, Brown County. October, 1935.
LC-USF 33–4054-M3 *Theodor Jung.*

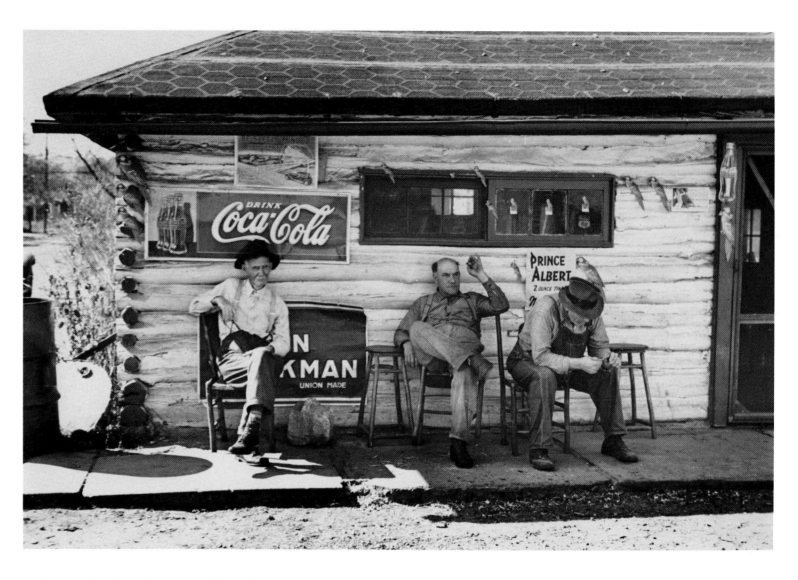

A noon-day siesta in front of a lunchroom, Helmsburg. October, 1935. LC-USF 33–4030-M1 *Theodor Jung*.

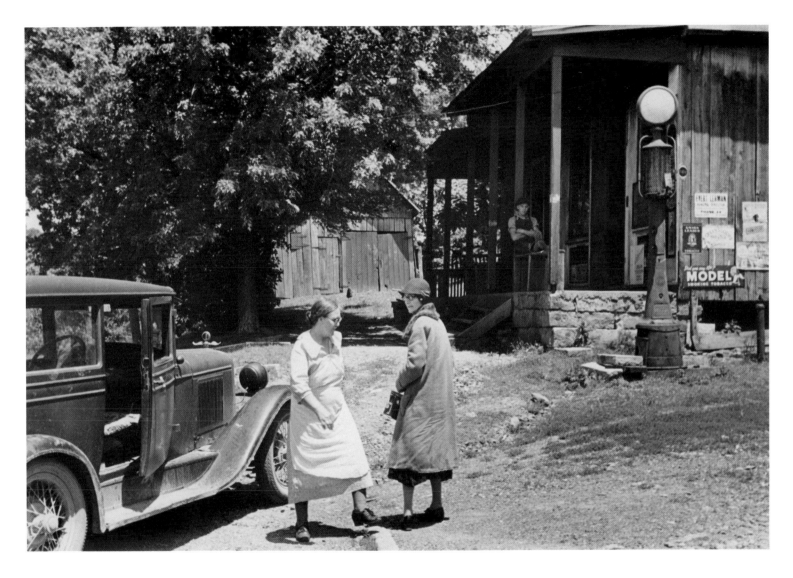

Farmers' wives about to enter the general store. Blankenship, Martin County. May, 1938.
LC-USF 33–2754-M5 *Arthur Rothstein.*

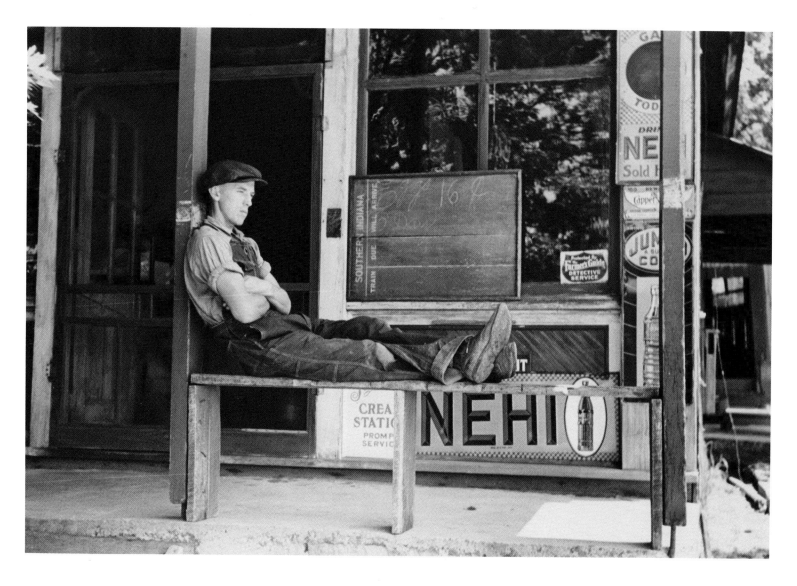

Resting in front of the general store. Blankenship. May, 1938. LC-USF 33–2751-M1 *Arthur Rothstein.*

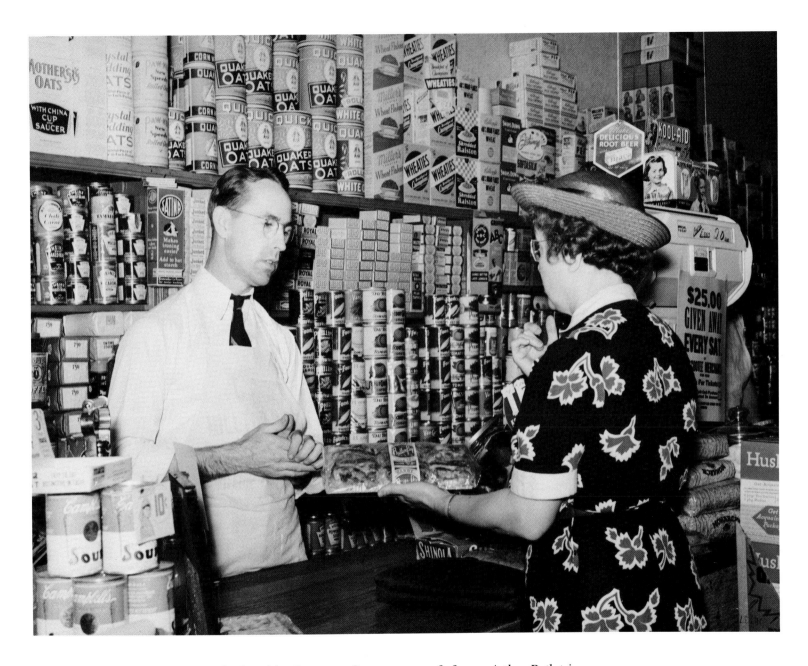

Buying groceries in a store. Blankenship. June, 1938. LC-USF 34–26463-D *Arthur Rothstein.*

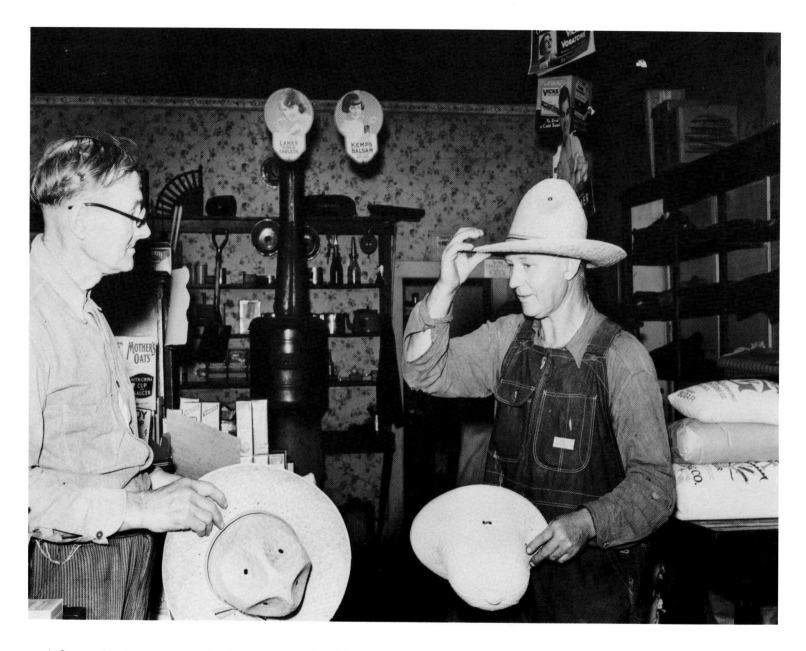

A farmer buying a new hat in the store. Blankenship Crossroads. June, 1938. LC-USF 34–26458-D *Arthur Rothstein.*

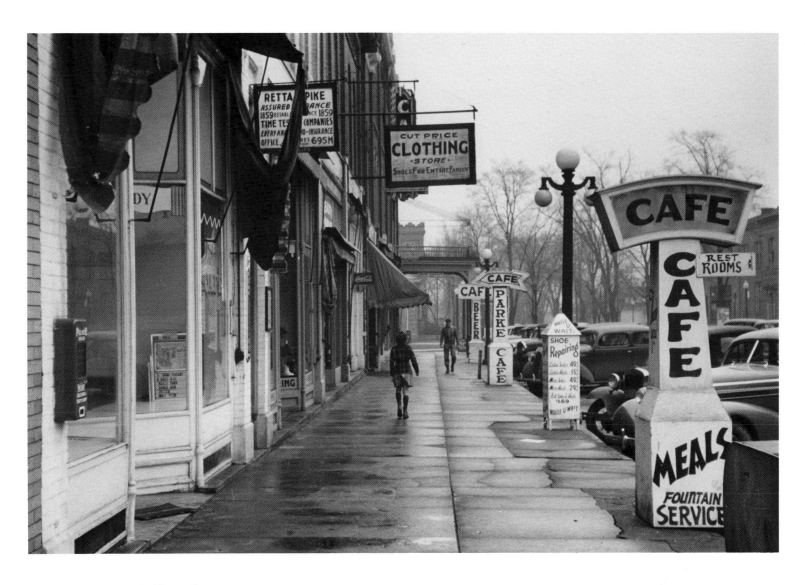

Main Street. Rockville. February, 1940.
LC-USF 33–3514-M4 *Arthur Rothstein.*

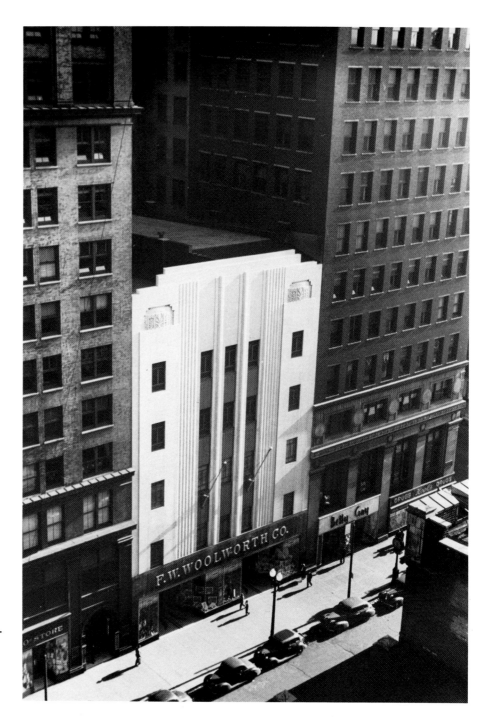

Woolworth Company store. Indianapolis.
May, 1940.
LC-USF 33–1874-M2
John Vachon.

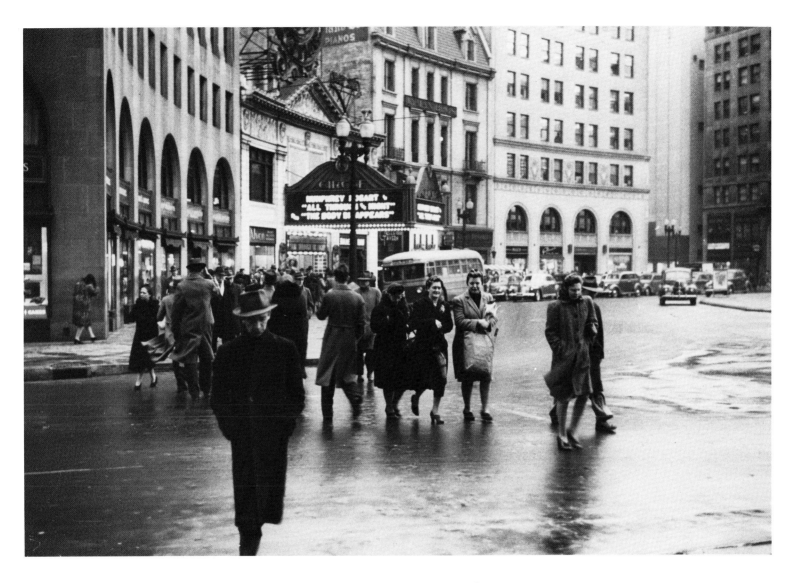

A rainy day. Indianapolis. January, 1942. LC-USF 33–16202-M2 *John Vachon.*

Uncompleted hotel on the main street of Vincennes. It was started in 1929 but was never completed because of the Depression. June, 1938.
LC-USF 34–26442-D
Arthur Rothstein.

Sign in Turkey Run Park.
Parke County. February, 1940.
LC-USF 33–3537-M1
Arthur Rothstein.

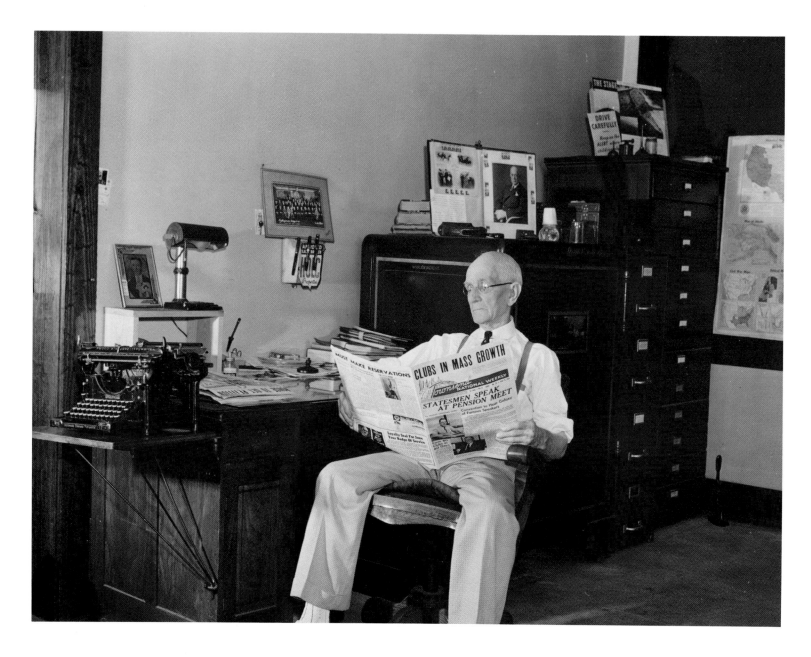

John W. Dillard, real estate and insurance man, and a member of the local Townsend club in his office. Washington. June, 1941. LC-USF 34–62997-D *John Vachon.*

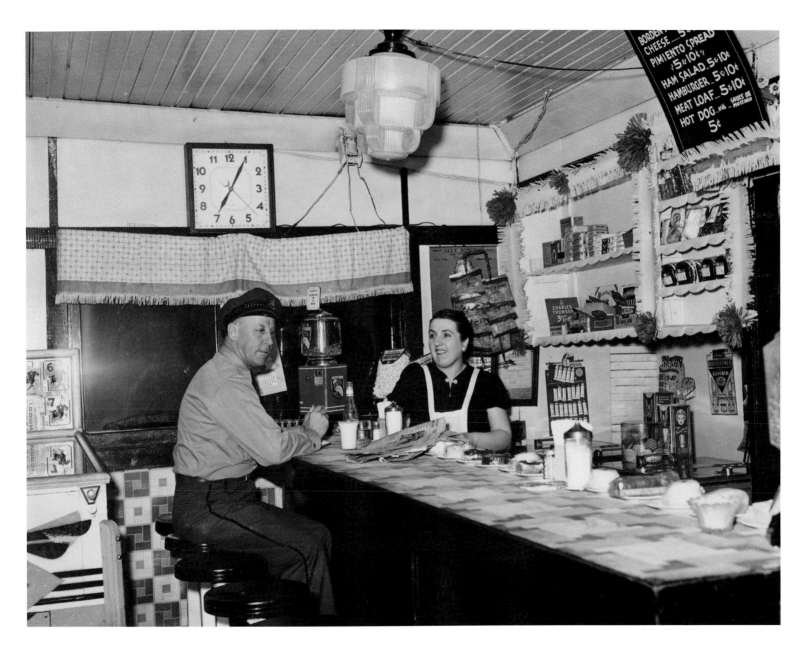

Truck driver in a diner. Clinton. February, 1940. LC-USF 34–29480-D *Arthur Rothstein.*

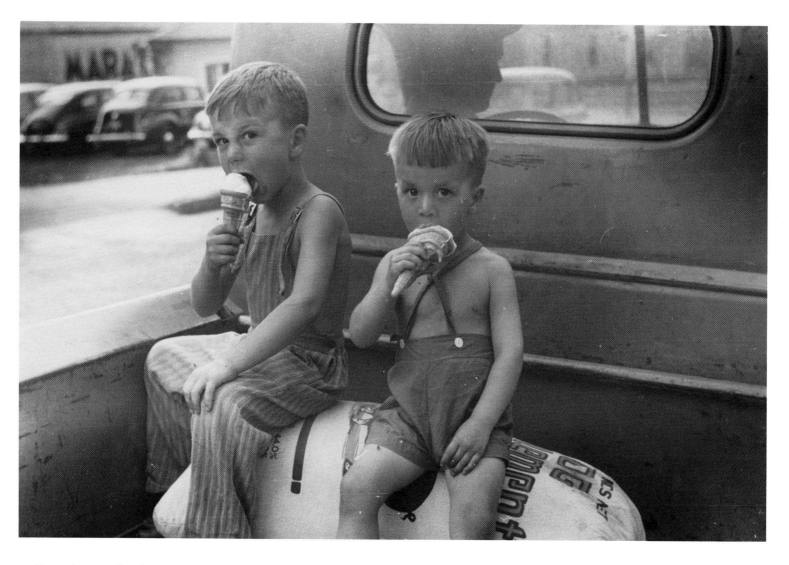

Farm boys eating ice-cream cones. Washington. July, 1941. LC-USF 33–16109-M3 *John Vachon.*

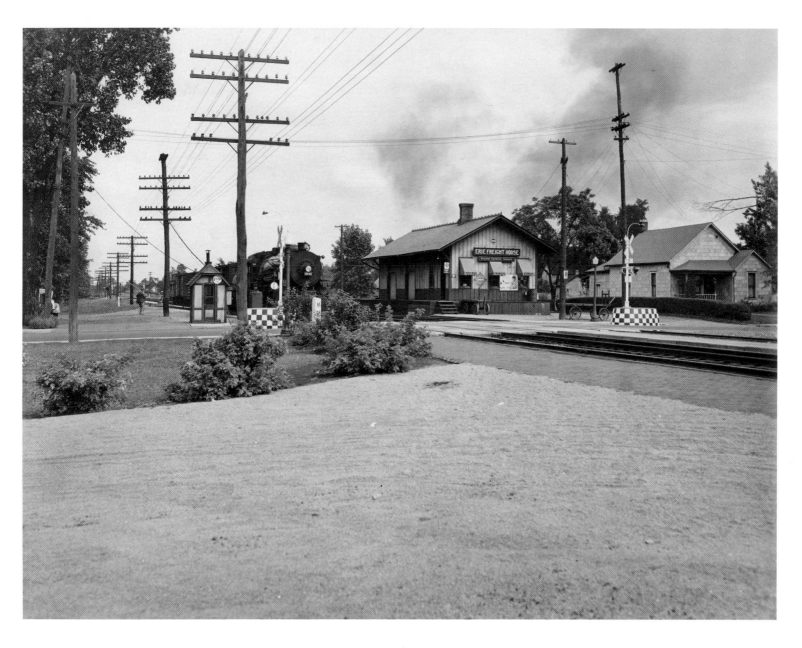

The Erie Railroad tracks and U.S. Highway 27. Decatur. September, 1935. LC-USF 342–118A *Photographer unknown.*

A Farm Auction

NOWHERE IS THE DECLINE of the family farm revealed more dramatically than in images of farm auctions. The large number of auctions at the time reflected the high mobility in the countryside. Those at the bottom, hired hands and tenant farmers, were the most likely ones involved. In 1935 more than thirty percent of Indiana's farmers had lived on the same farm less than five years. The consequences of this high mobility, particularly among non-owner operators, was described in a 1938 FSA research report: "The incessant movement from farm to farm and community to community of families living under such conditions constitutes a disintegrating influence upon all social institutions. . . . Systematic church attendance is impossible, neighborhood relations are constantly disrupted, and the children of tenant parents find their school attendance periodically interrupted."

Most farm auctions were held in late winter. Sales reached their peak in February as sellers anticipated the property tax assessment due on the first of March. Russell Lee covered the Frank Sheroan auction on February 25, 1937. He expressed his thoughts about the subject as follows: "I would shoot several different pictures—different facets of the auction. It might be the auctioneers or the audience, or even a pile of belongings. It was not exactly a picture story—not yet—but I was after the many sides of the auction."

Sheroan was a tenant farmer in Tippecanoe County. This series includes the notice of the sale, the tenant and his wife before the auction, the sale of cows, pigs, horses, and machinery and the settling up afterward. Pictures of the elaborate lunch served by neighbor ladies, the three helpers shivering in the cold, and Sheroan desperately pleading for higher prices for his livestock are especially dramatic. Yet, as with so much of Lee's work, the images are not contrived but document the event in a factual manner.

Roy Stryker described Lee as a taxonomist with a camera: "He takes apart and gives you all the details of the plant. He lays it on the table and says, 'There you are, Sir, in all its parts.' "

CLOSING OUT SALE

I will sell at Public Auction at my residence, on the Jim Fay farm, located 6 miles west of Lafayette; 3 miles east of Montmorenci, on

THURSDAY, FEBRUARY 25

Commencing at 10:30, the Following Described Property:

HORSES—3 HEAD

One gray gelding, 10 years old, weight 1700; 1 gray mare, 11 years old, weight 1500; 1 gray gelding, 9 years old, weight 1600. All sound and good workers.

CATTLE—10 HEAD

Seven extra good milk cows, all good ages; 3 heifers, some of these are springers and some giving good flow of milk; 2 small calves; 1 heifer, will be fresh in spring.

HOGS

Two sows, bred to farrow about April 1; 14 shoats, weight 85 to 100 lbs.

IMPLEMENTS—Two wagons; 1 sulkey breaking plow; 1 walking plow; 1 corn plow; 1 roller; 1 good manure spreader; 1 harrow; 1 disc; 1 mowing machine; 1 hay rake; 1 disc cultivator; 1 corn planter; 1 set of almost new team breeching harness; a lot of small tools.

HOUSEHOLD GOODS—One dining room set, buffet, table and chairs; 1 cream separator, just used a short time; 1 laundry stove; 1 cooking range, and other articles will be sold. TERMS—CASH

FRANK SHEROAN, Owner

JOHN JARREL, Auctioneer LEONARD GATTON, Clerk

Notice of the Frank Sheroan sale appeared in the Montmorenci, Indiana newspaper. February, 1937.
LC-USF 3780-ZB *Russell Lee.*

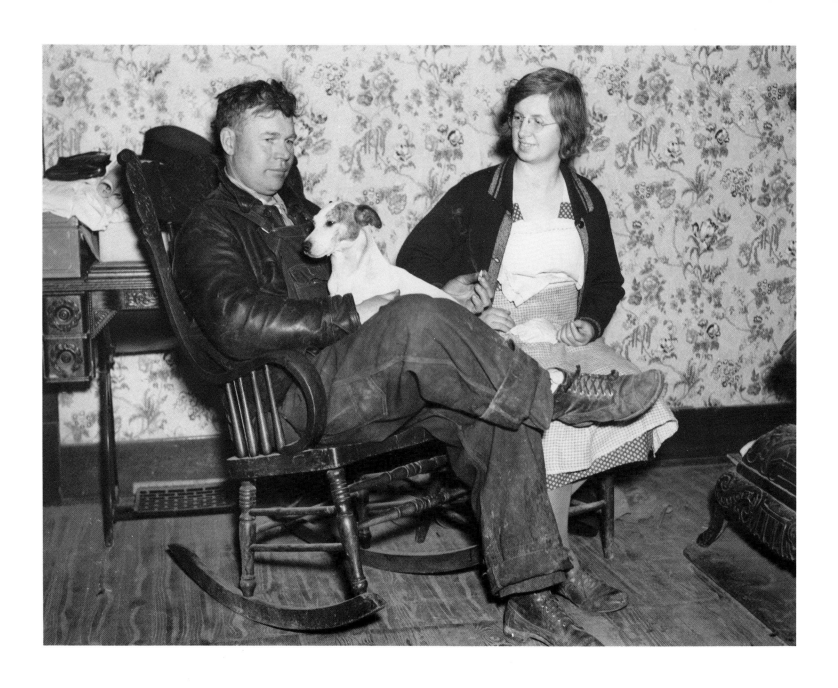

Mr. and Mrs. Frank Sheroan, tenant farmers, and their dog, at home near Montmorenci. February, 1937.
LC-USF 34–10380-D *Russell Lee.*

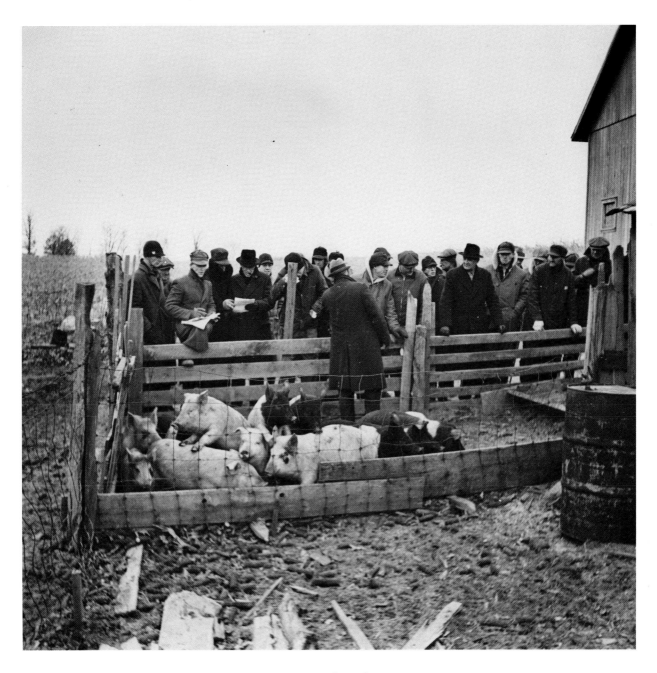

Auctioning pigs at Frank Sheroan's closing out sale. February, 1937.
LC-USF 34–10393-E *Russell Lee.*

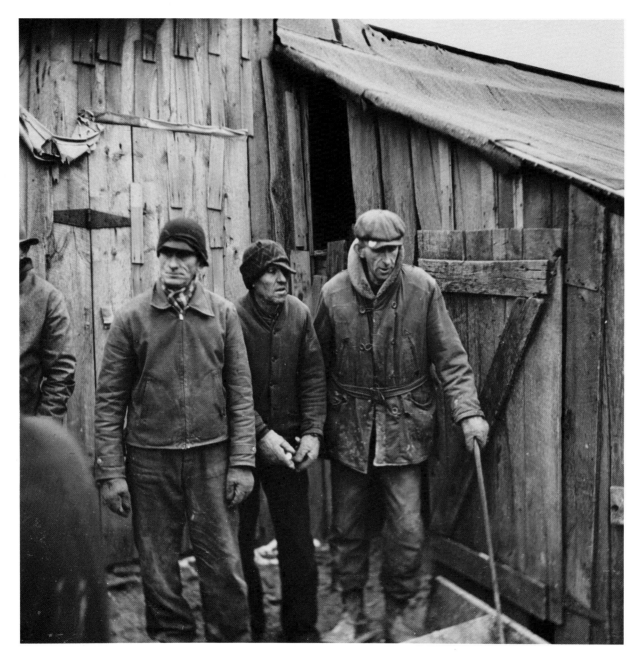

Three helpers at Frank Sheroan's sale. February, 1937. LC-USF 34–10383-E *Russell Lee.*

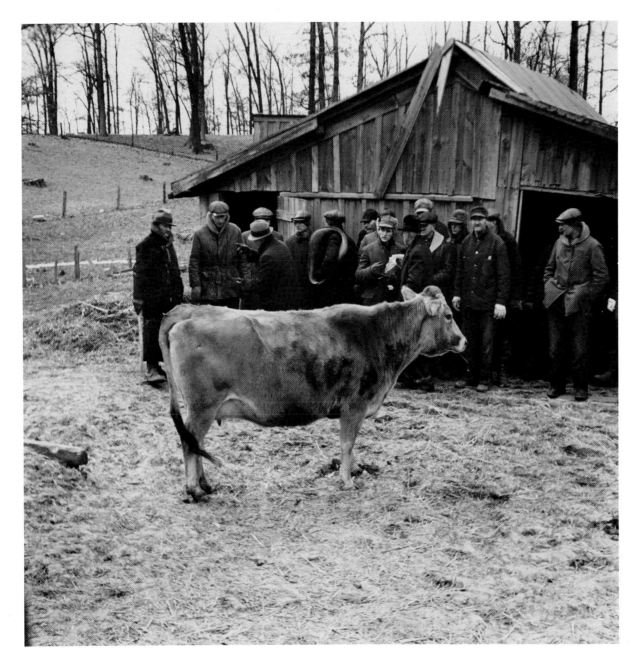

Auctioning a cow at Frank Sheroan's closing out sale. February, 1937.
LC-USF 34–10390-E *Russell Lee.*

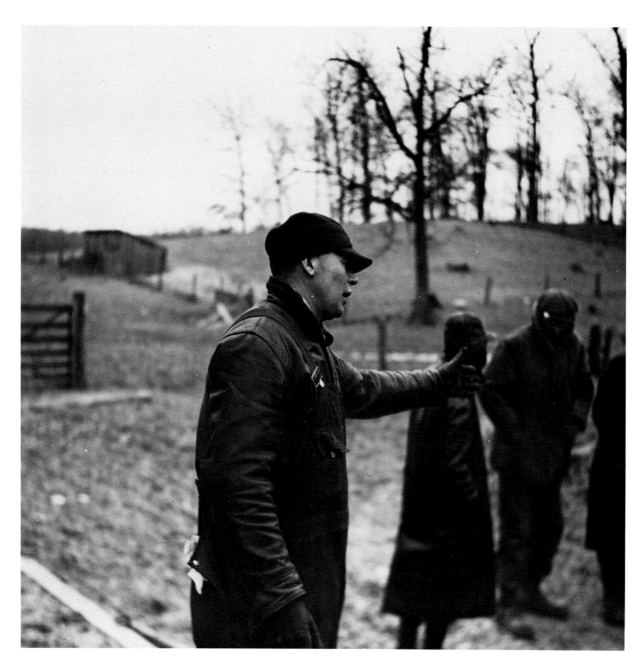

Frank Sheroan pleading for a better price on his livestock. February, 1937.
LC-USF 34–10379-E *Russell Lee.*

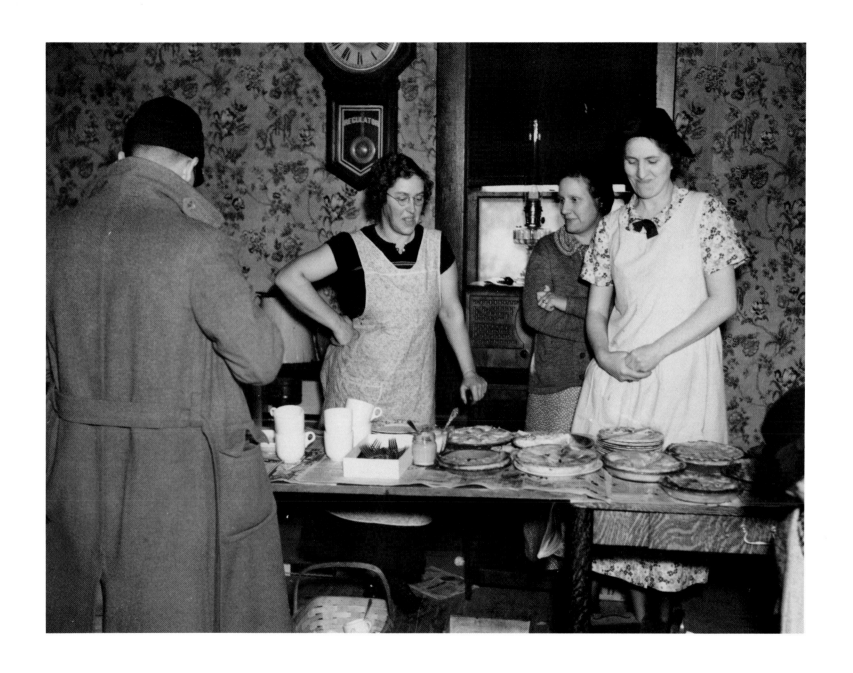

Lunch was served in the farmhouse by neighbor ladies during Frank Sheroan's closing out sale. February, 1937.
LC-USF 34–10389-D *Russell Lee*.

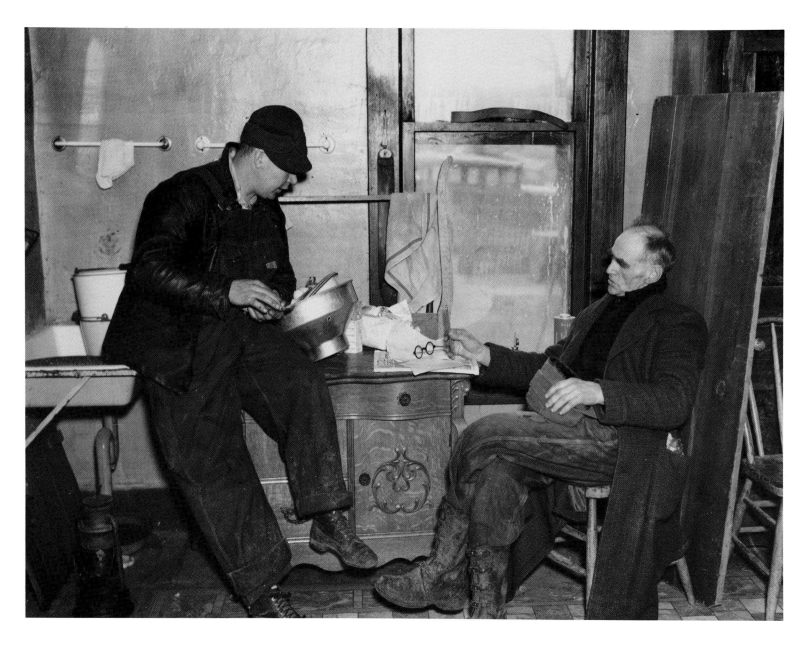

Settling up after the sale on Frank Sheroan's farm. February, 1937. LC-USF 34–10396-D *Russell Lee*.

At Work

DURING THE 1930s Hoosiers earned their livings in many ways. Since the FSA photographers were concerned primarily with rural life, there is little documentation of the state's major industries including iron and steel, automobile production, and petroleum refining. Instead, the photographs emphasize traditional agricultural labor: planting, harvesting, and threshing. Perhaps the most notable selections are those of Dorothea Lange, best known for her photographs of the Far West and, in particular, migrant workers. In the summer of 1936 she took a series of pictures of threshing oats. The photographs convey the nature of this hard and dirty job with its crew of bundle wagon operators, pitchers, and water boys. Many years later, Lange recalled that in the course of her FSA work she "got interested in the way in which agriculture was being mechanized." As more and more farmers began to harvest their crops with combines, threshing crews became a rare sight.

Sorghum, a substitute for molasses, was by the 1930s primarily grown to attract the fall tourists visiting Brown County. The photograph by Theodor Jung depicts an evaporator in which the liquid drawn from the canes was boiled for several hours. The attendants are using long-handled wooden paddles to skim off excess foam and impurities.

The other pictures in this group present a variety of activities. Canning was a common FSA subject. In the field, the photographer often traveled with the county agent. The agent with the camera was employed by Purdue University; statewide responsibility for agricultural extension was assigned to Purdue in 1937. In his coverage of northwestern Indiana, Russell Lee photographed successful farms. Shown here are Mary Lah's barn and silo. The most heartwarming pictures are those of Charles Miller, who had been a hired hand, and his wife, in the process of moving to the farm he will work as a tenant farmer. The photograph of a homemade pile driver was taken by Paul Carter, the lighthearted auction scene from Owensburg by Arthur Rothstein, and the somber shot of a casket and mortuary attendants at the railway station in Shelbyville by John Vachon.

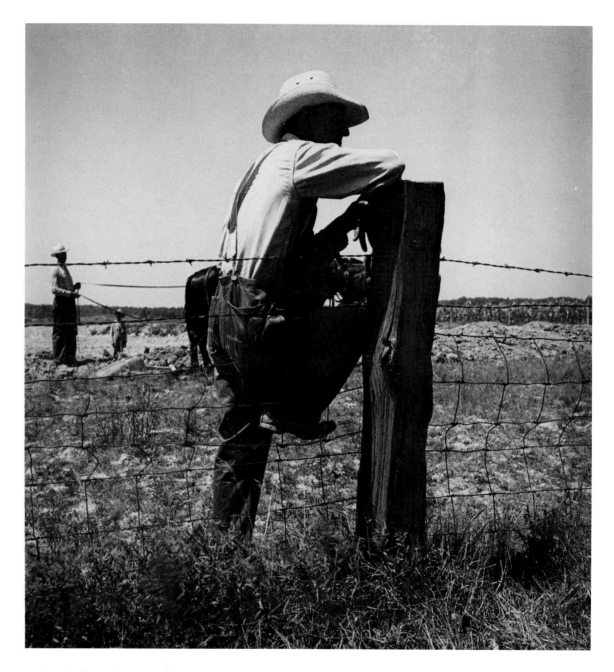

An Indiana farmer. August, 1936. LC-USF 34–9759-E *Dorothea Lange.*

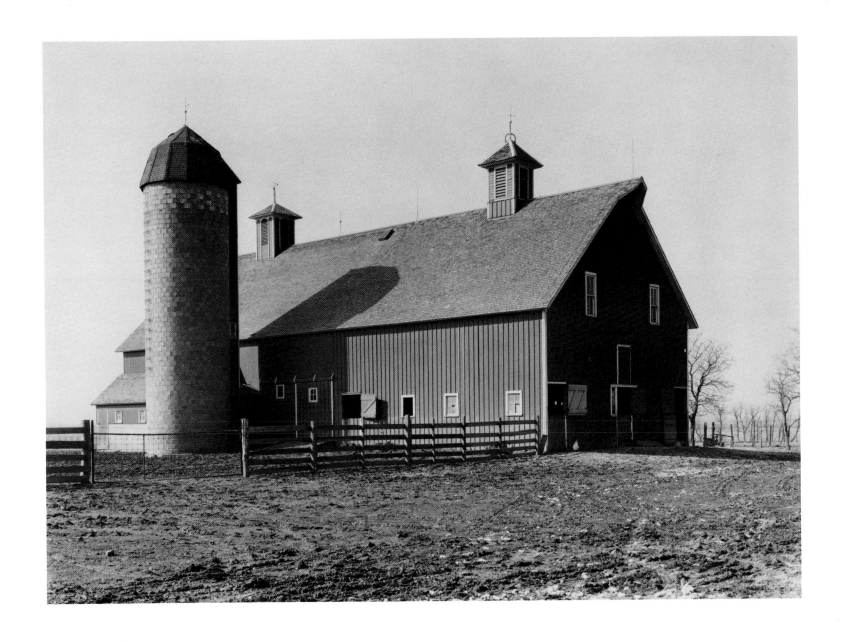

Barn and silo on the owner-operated farm of 230 acres belonging to Mary Lah, a widow. This farm, which has carried a small mortgage since the Depression, lies near the state line of Illinois and Indiana in the vicinity of Fowler. February, 1937. LC-USF 341–10486-B *Russell Lee*.

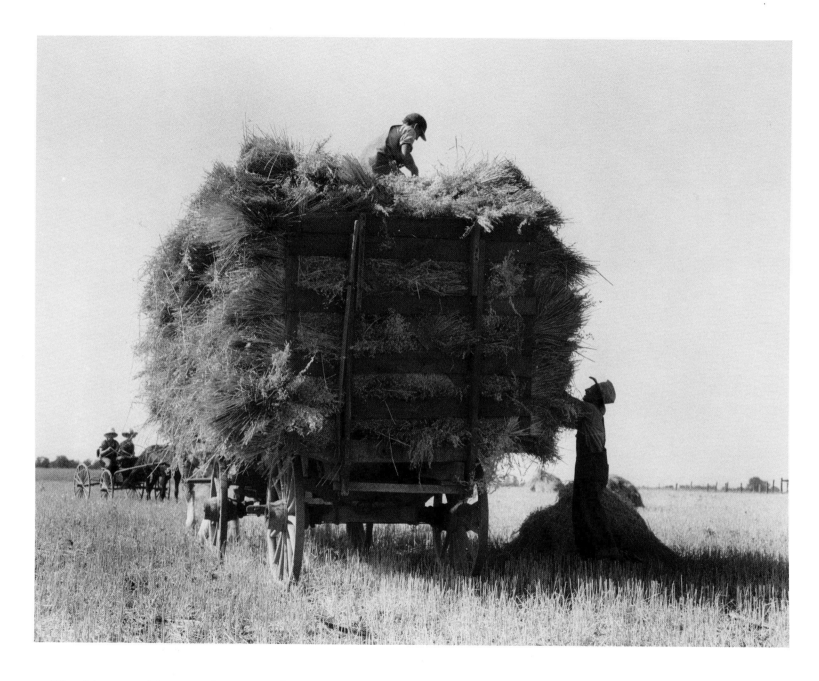

Threshing oats. Clayton. July, 1936. LC-USF 34–9723-C *Dorothea Lange.*

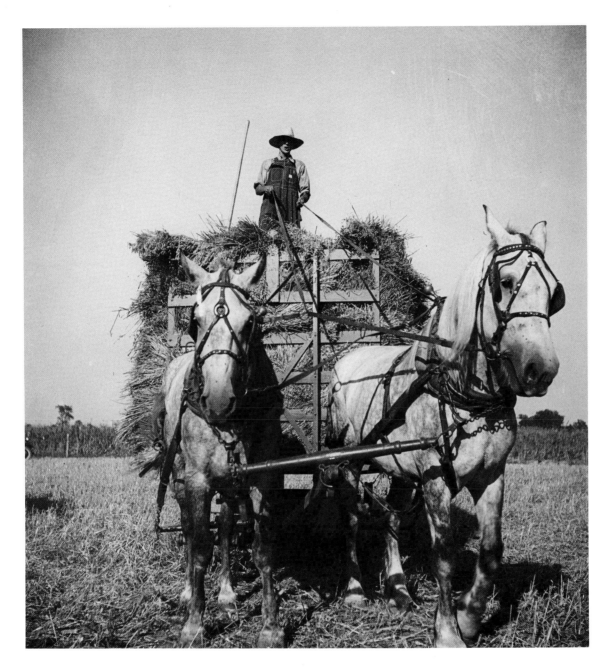

Harvesting oats. Clayton. July, 1936. LC-USF 34–9711-E *Dorothea Lange.*

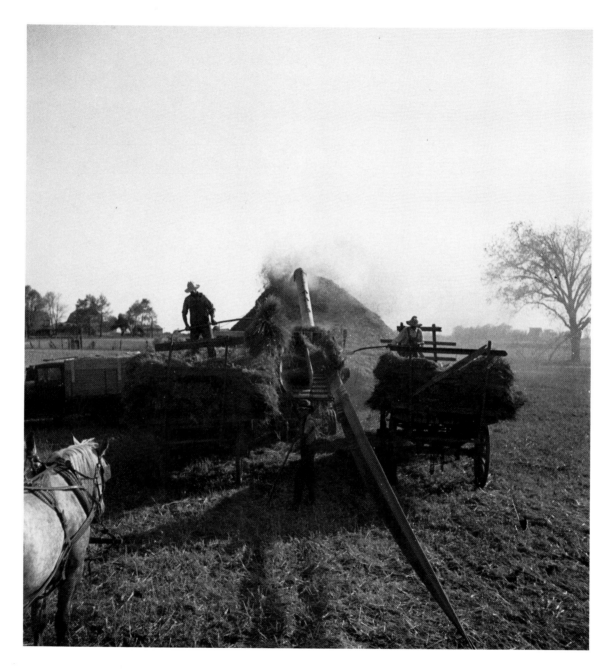

Threshing oats. Clayton. July, 1936. LC-USF 34–9710-E *Dorothea Lange.*

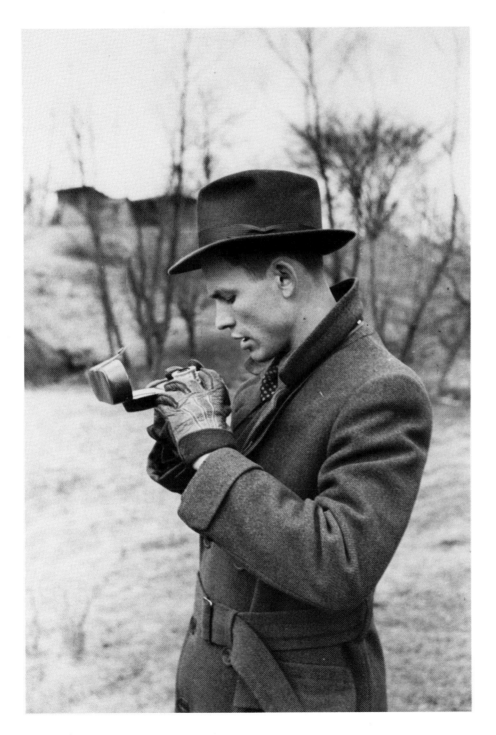

The county agent taking pictures.
Parke County. February, 1940.
LC-USF 33−3543-M4
Arthur Rothstein.

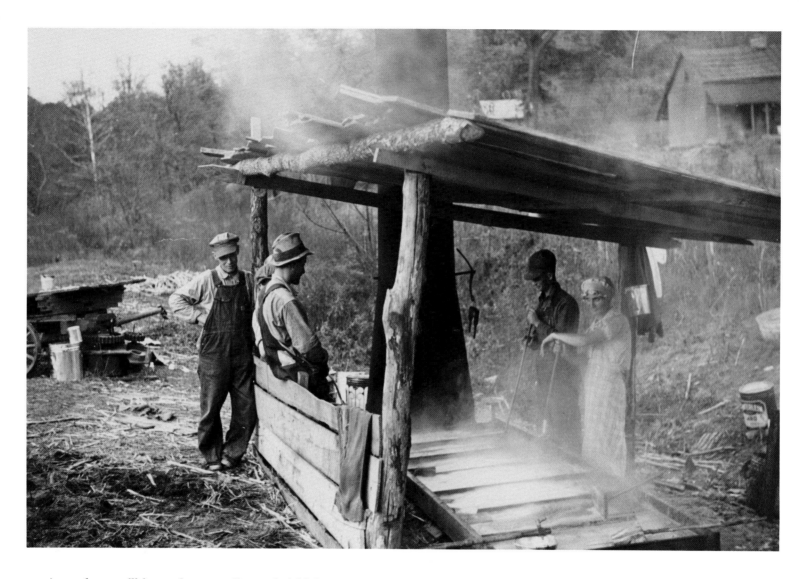

A sorghum mill located on a well-traveled highway near Nashville. October, 1935.
LC-USF 33–4034-M2 *Theodor Jung.*

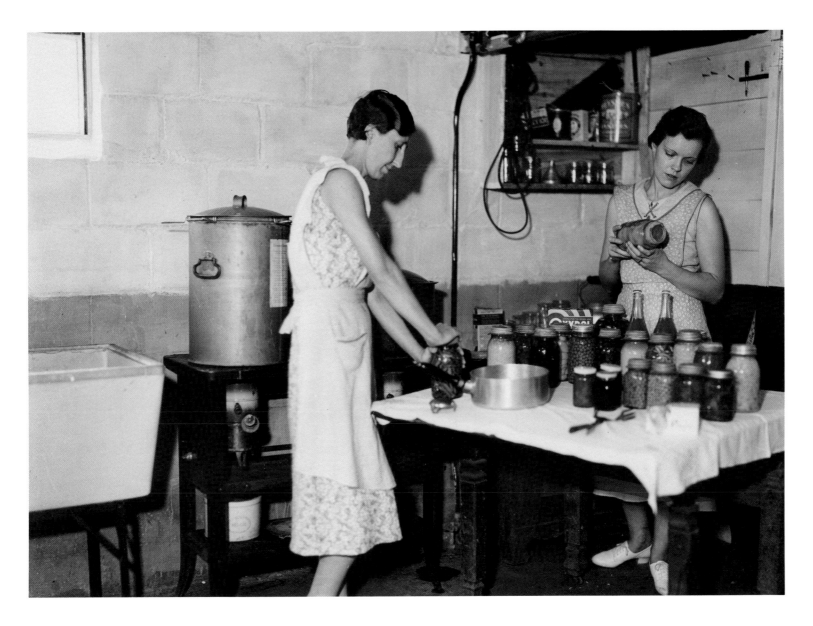

A rural rehabilitation project of the U.S. Resettlement Administration. Canning vegetables in one of the homes. Decatur Homesteads. April, 1936. LC-USF 341–11279-B *Paul Carter.*

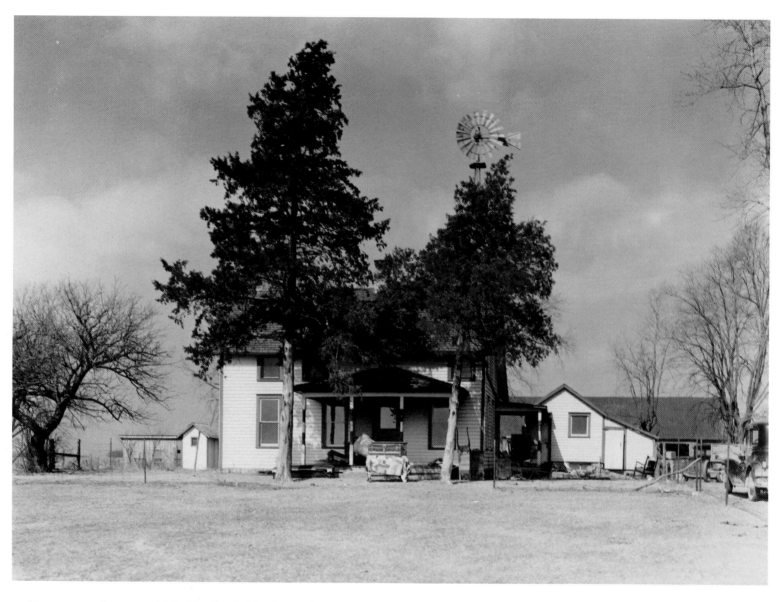

House on a farm to which Charles Miller is moving. A hired man for the past twelve years, Miller has now rented a farm near Fowler to work himself. February, 1937. LC-USF 341–10512-B *Russell Lee.*

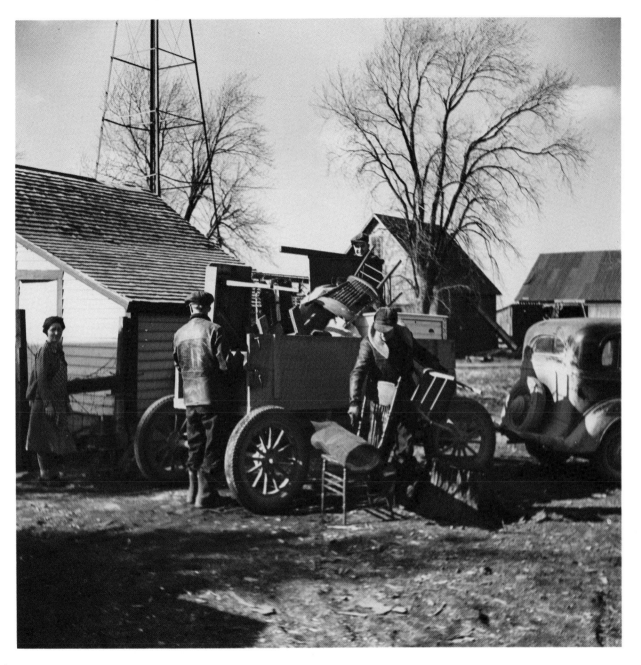

Charles Miller, moving his household goods onto the farm he has rented to work for himself. Near Fowler. March, 1937. LC-USF 34–10551-E *Russell Lee*.

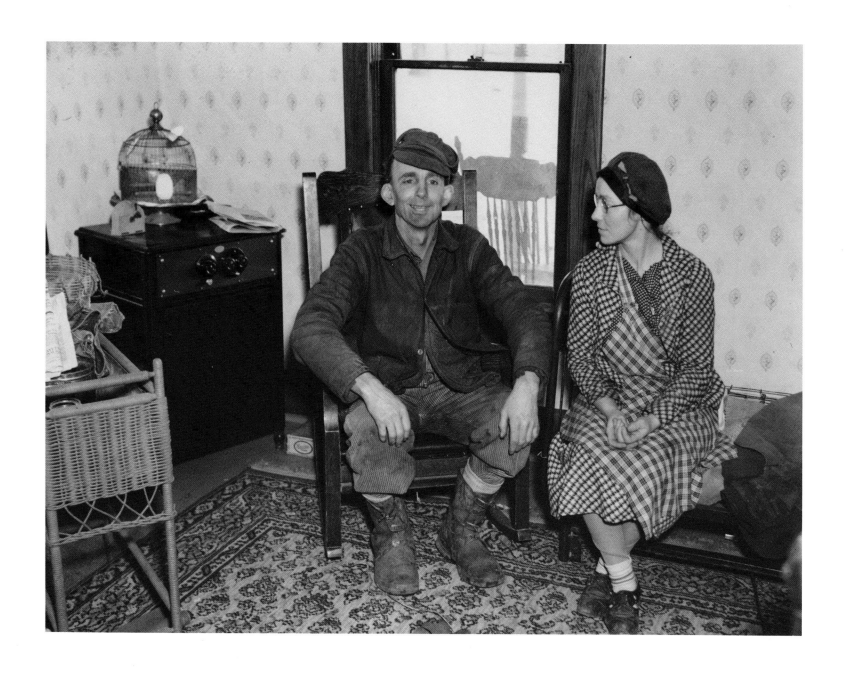

Charles Miller and his wife pausing in the midst of moving their property; heretofore he has always been a hired hand. Near Fowler. March, 1937. LC-USF 34–10562-D *Russell Lee.*

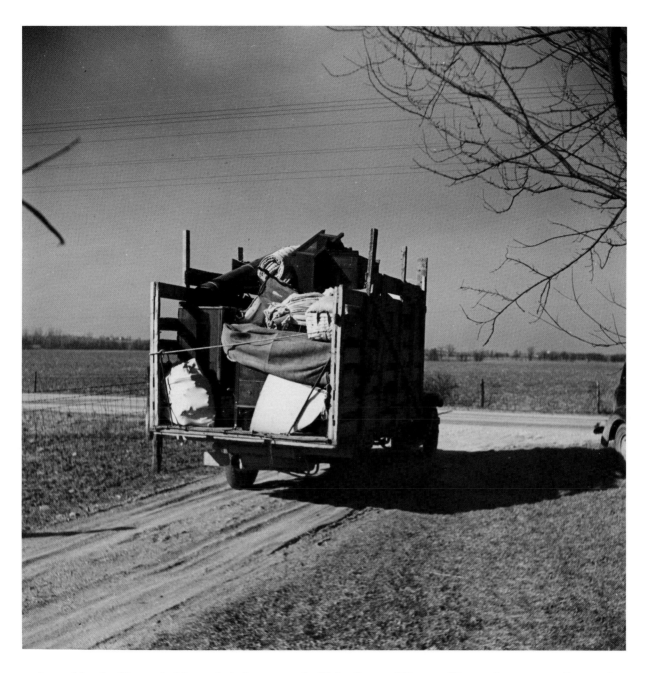

A truckload of household goods being moved off the farm of Everett Shoemaker, tenant farmer, near Shadeland. February, 1937. LC-USF 34–10367-E *Russell Lee.*

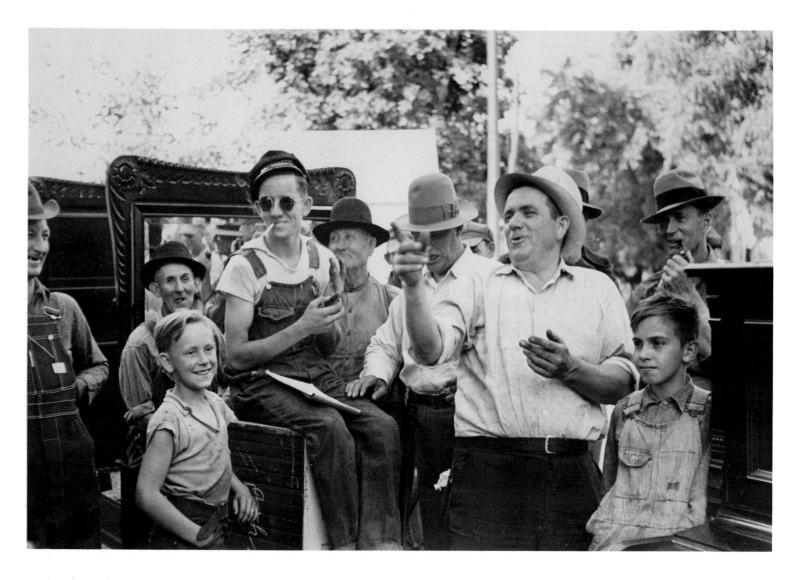

Auction sales in Green County are frequent because as farm conditions become worse, families move into smaller houses and sell excess furniture. Owensburg. May, 1938.

LC-USF 33–2761-M1 *Arthur Rothstein.*

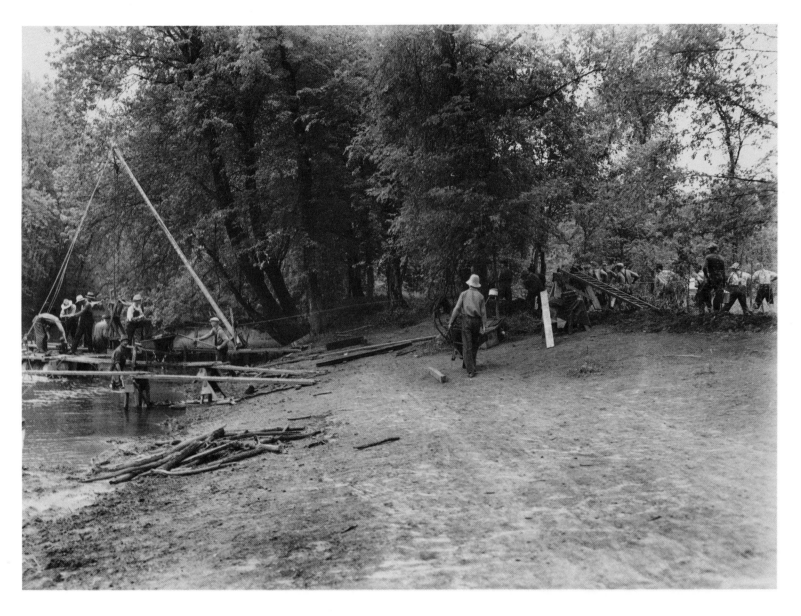

A homemade pile driver. The men on the right run backward hoisting the hammer on the left, then slack off and repeat, thus driving a pile to form current diversion in a national park area developed on submarginal land by the U.S. Resettlement Administration. Near Winona. June, 1936. LC-USF 341–11129-B *Paul Carter.*

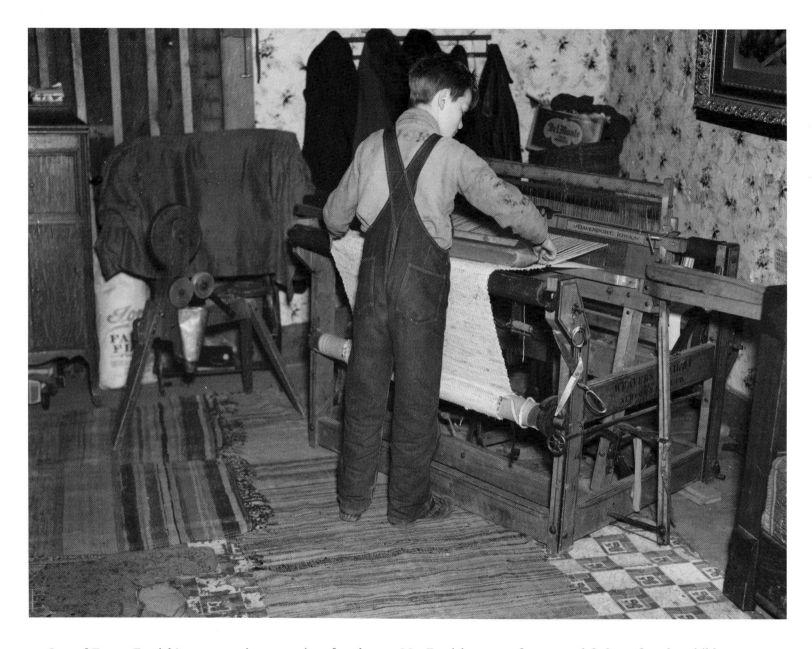

One of Evasty Emrich's sons weaving a rug in a farmhouse. Mr. Emrich, tenant farmer and father of twelve children, also weaves in his spare time. Battleground. March, 1937. LC-USF 34–10529-D *Russell Lee.*

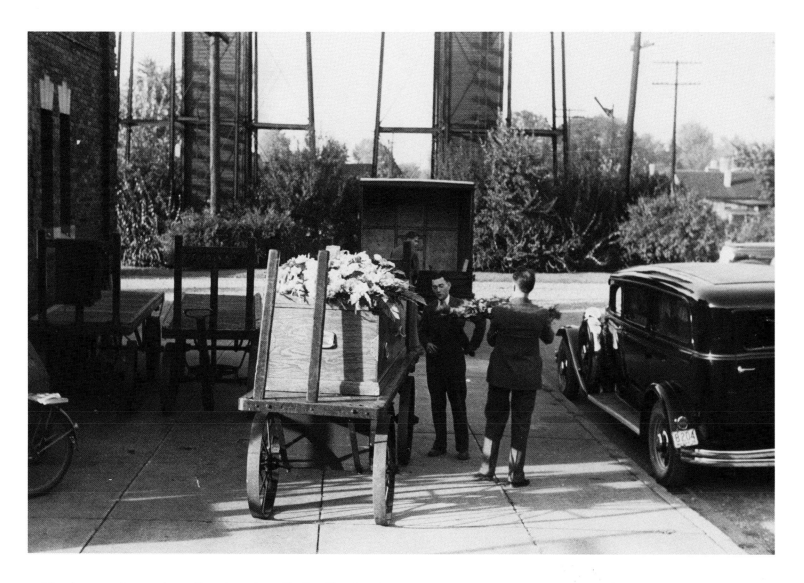

Meeting a casket at the railroad station. Shelbyville. October, 1939.
LC-USF 33–1206-M5 *John Vachon.*

A Day in the Life of a Hired Hand

DURING THE GREAT DEPRESSION, as many as one-third of American farm families lived in conditions "so low as to make them slum families." The most desperately poor were the farm laborers, sharecroppers, and tenant farmers. In Indiana in 1935, more than 21,000 rural families were on relief. These people were struggling to maintain themselves, even while they were being stigmatized by some vocal spokespersons for the successful as lacking in ambition and self-respect. In looking back, the Resettlement Administration was the major striking force in the nation's first war against poverty. The Historical Section helped to mobilize public and congressional sympathy for this crusade.

Soon after Russell Lee joined the Historical Section, he traveled to the Midwest. From Iowa and Illinois he exchanged letters with Stryker; these letters noted the "great demand now for pictures of farm tenancy" and suggested that the Resettlement Administration "may have jurisdiction over the new tenancy bill." Stryker encouraged Lee to spend time with one family, "photographing all aspects of their life and activities." The resulting series focused on the Tip Estes family of Benton County, Indiana.

The highest concentration of non-owner operated farms in Indiana was in the northwestern counties of Benton, Newton, and White. More than half the farms in those three counties were operated by farm laborers and tenants. In contrast, less than twenty percent of the farms in sixteen southern Indiana counties were farmed by this method. Benton County was the richest Indiana agricultural county in proportion to its size, yet it was characterized by poor housing conditions and excessive soil depletion. The reasons for this seeming paradox were a century old. In the 1830 land speculators in the East purchased these rich farmlands. When Henry L. Ellsworth, the major absentee investor, died in 1858, he owned more than 74,000 acres in Benton County. This pattern of ownership, which did little to foster new technology and development, continued well into the twentieth century.

Russell Lee's ability to put people at ease with him and his camera was one of his outstanding characteristics. He was a gentle, friendly man, and people were easily persuaded to let him photograph them in their homes. His interior shots are among the best in the FSA collection. Lee said of these photographs:

> I became concerned with details in a place. I'd go into a bedroom and there might be something on a dresser that would interest me. It might be on a bedside table. Sometimes there would be mementoes of their travels; sometimes photographs; sometimes objects of art. It could be a religious symbol or a portrait of their parents. The things people kept around them could tell you an awful lot . . .

In this series, Tip Estes and his large family are shown in relaxed poses amidst their personal belongings. Russell Lee's mastery of the camera is evident in each of these photographs.

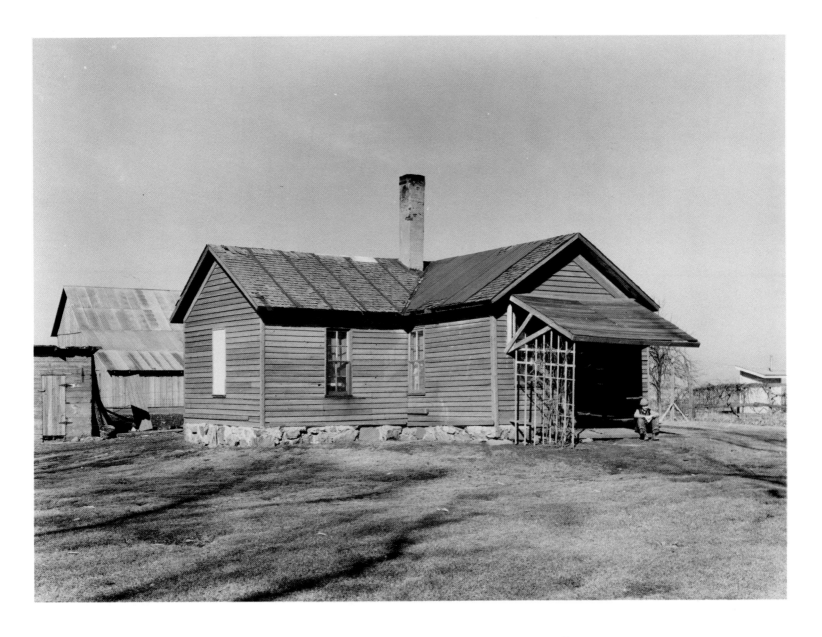

Home of Tip Estes, hired man, near Fowler. March, 1937. LC-USF 341–10603-B *Russell Lee.*

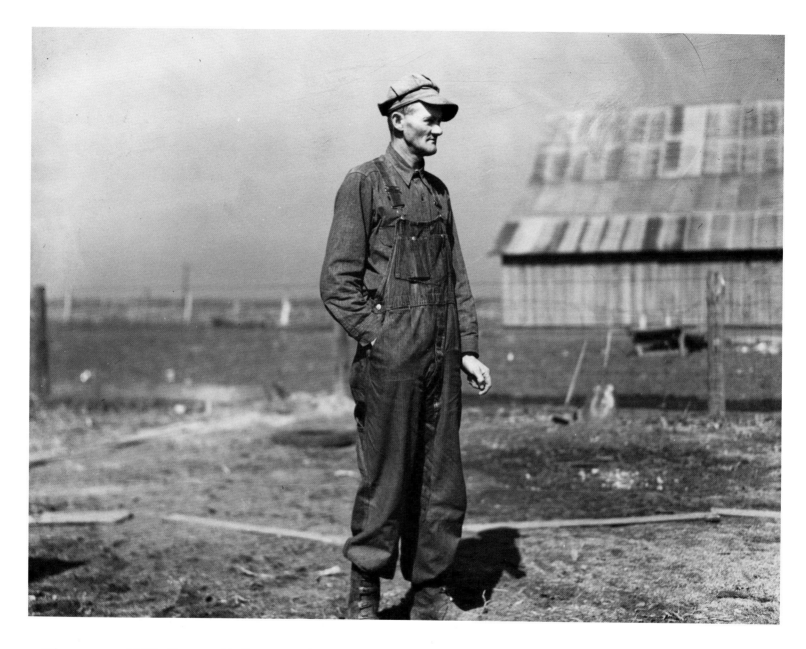

The 43-year-old Tip Estes on his farm. March, 1937. LC-USF 34–10565-D *Russell Lee*.

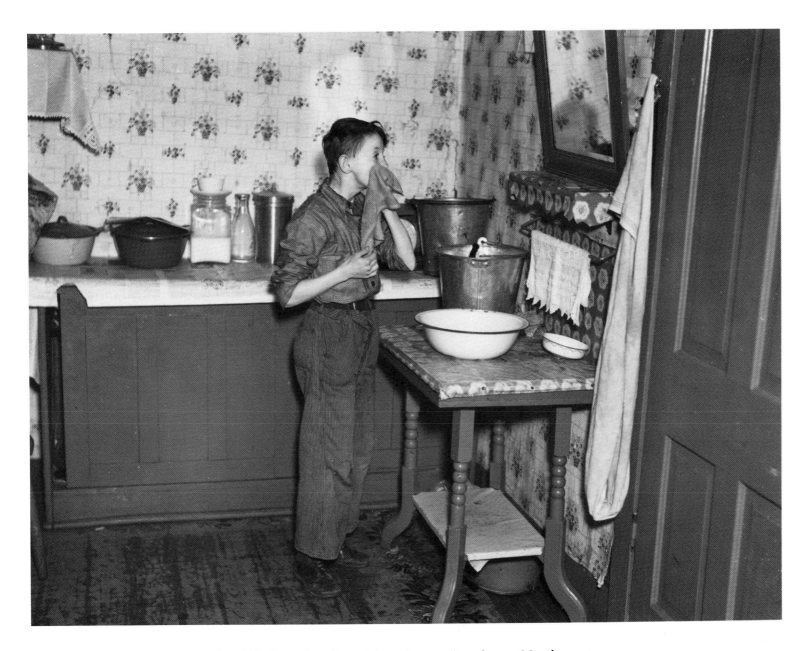

6:45 a.m. Tip Estes' son washing his face after doing his early morning chores. March, 1937.
Russell Lee.

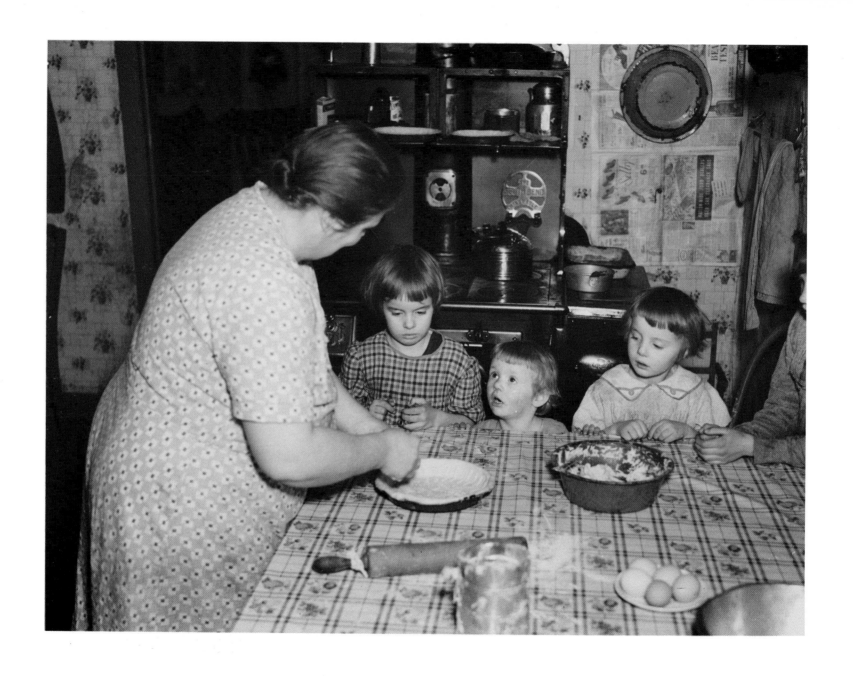

7:45 a.m. Tip Estes' children watching their mother make a pie. March, 1937. LC-USF 34–10575-D *Russell Lee*.

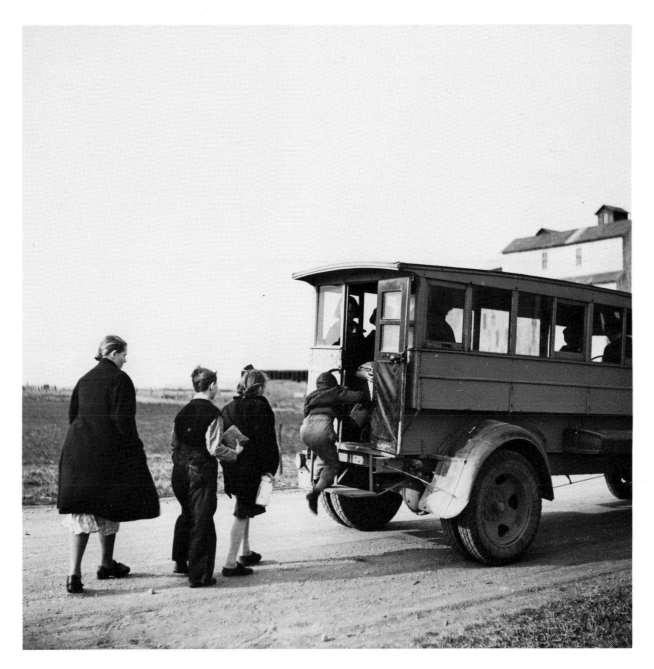

Tip Estes' children boarding a school bus. April, 1937. LC-USF 34–10707-E *Russell Lee.*

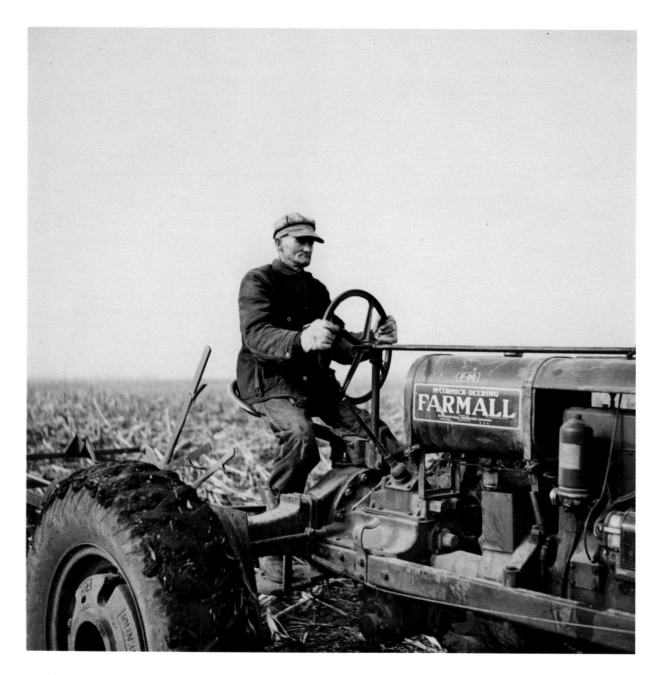

Tip Estes operating a tractor. April, 1937. LC-USF 34–10710-E *Russell Lee*.

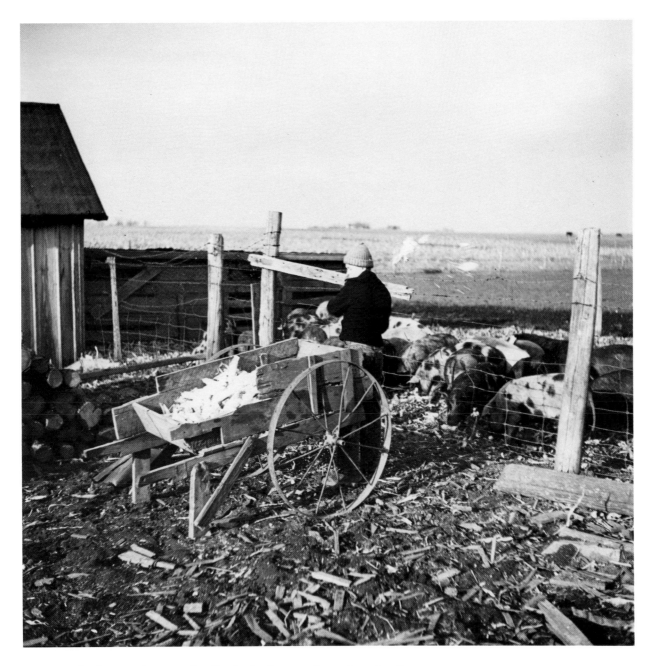

One of Tip Estes' sons, who feeds the hogs twice a day. April, 1937.
LC-USF 34–10711-E *Russell Lee*.

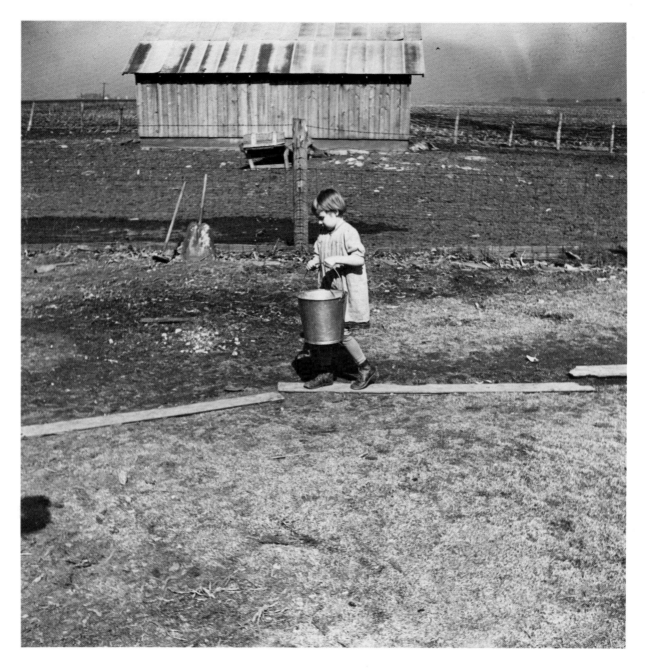

Child of Tip Estes going after water. March, 1937. LC-USF 34–10549-E *Russell Lee.*

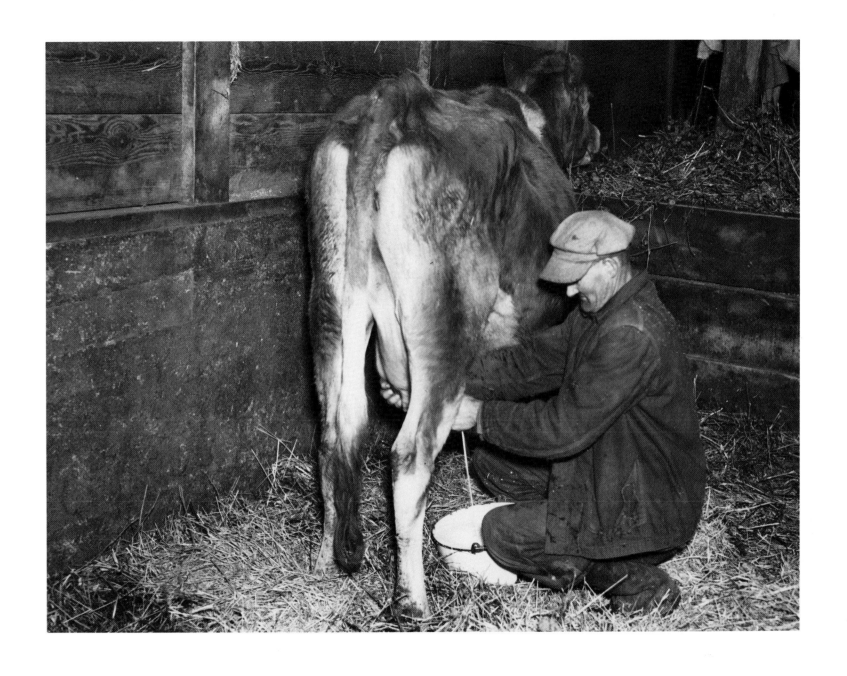

Tip Estes milking a cow. March, 1937. LC-USF 34–10579-D *Russell Lee.*

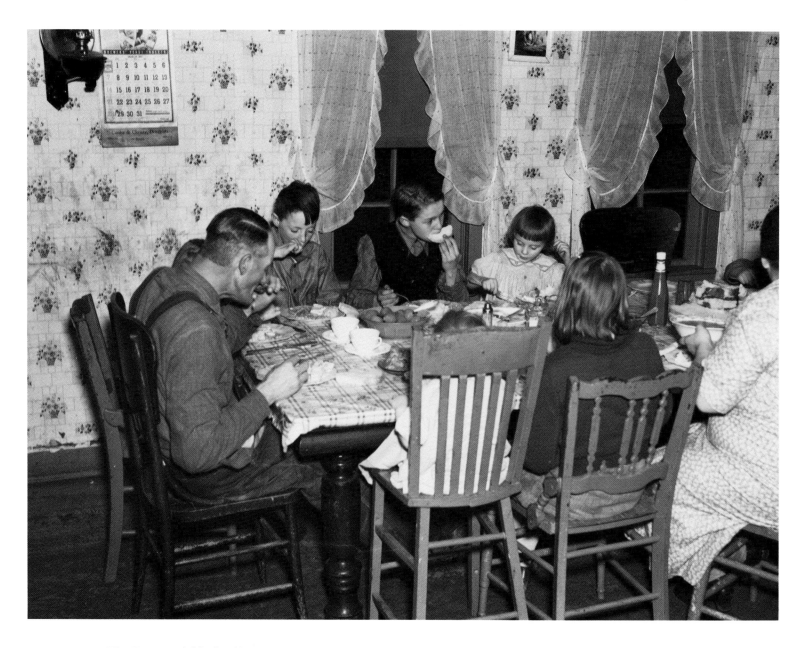

7:10 p.m. Tip Estes and his family eating dinner. The day's work has been finished, Tip Estes has washed up, and dinner is served. March, 1937. LC-USF 34–10580-D *Russell Lee.*

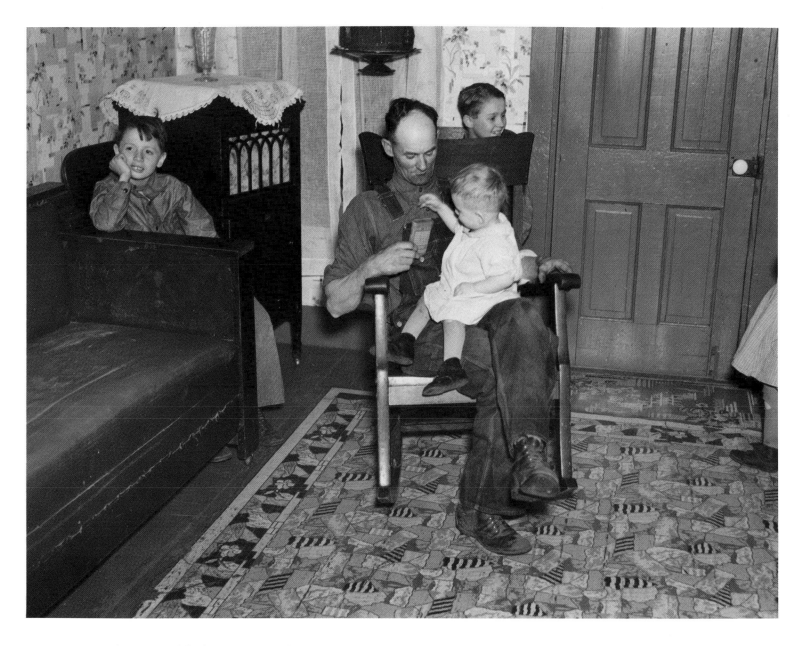

7:40 p.m. Tip Estes, with the youngest of his nine children. After dinner, the family sits around until 8:00 or 8:30 when they go to bed. There is no reading matter in the house. March, 1937. LC-USF 34–10581-D *Russell Lee.*

At Play

HARD TIMES DID NOT CAUSE Hoosiers to abandon the myriad ways they sought pleasure and relaxation. The selections chosen illustrate the broad range of subject matter Roy Stryker encouraged. Picnics, fairs, card games, and baseball were popular activities covered by the photographers. Arthur Rothstein's picture of high school students playing pool despite the sign's admonition, "Do not play pool," is a humorous comment on adolescence. His lighthearted touch is also seen in the picture of the well-dressed pinsetter.

Indiana's most famous sports extravaganza is the Indianapolis 500. Billed as the World's Greatest Sporting Event, the Indianapolis 500 was first run in 1911 at the 2½ mile track built two years earlier. The Rothstein photograph depicts the return of single-seat racers authorized by Speedway President Eddie Rickenbacker in 1938. From 1911 to 1923 and again from 1930 to 1937, the cars were required to be two-seaters with both a driver and a mechanic. The 1938 race was won by Floyd Roberts, who set a record-breaking pace of 117.2 miles per hour; the following year Roberts was killed in a spectacular crash while attempting to defend his title. Held annually on Memorial Day, the 500 continues to enjoy world-wide fame.

John Vachon's photographs vignette a variety of relaxing Sunday pursuits—a picnic, a game of bridge, reading the newspaper, walking a fence, eating ice cream cones. Many of these scenes, taken in conjunction with assignments at Wabash Farms, conform to Stryker's small-town shooting scripts.

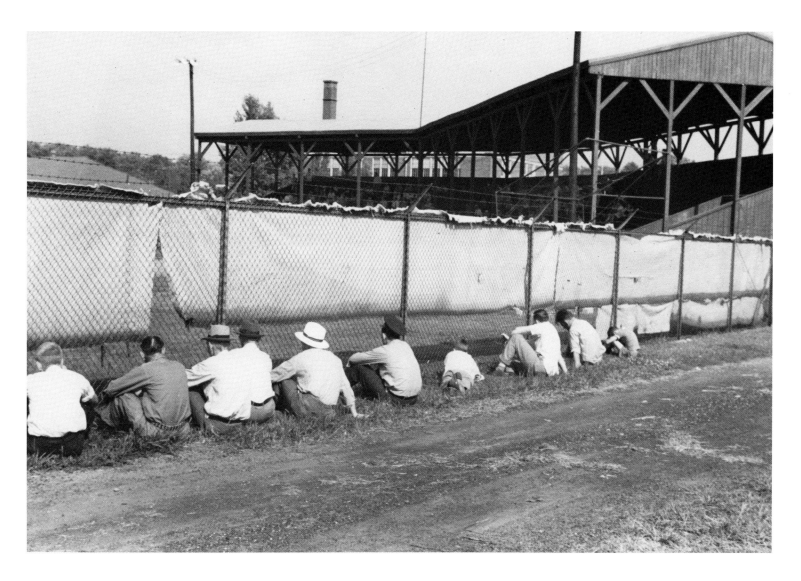

Watching a ball game. Vincennes. July, 1941. LC-USF 33–16086-M4 *John Vachon.*

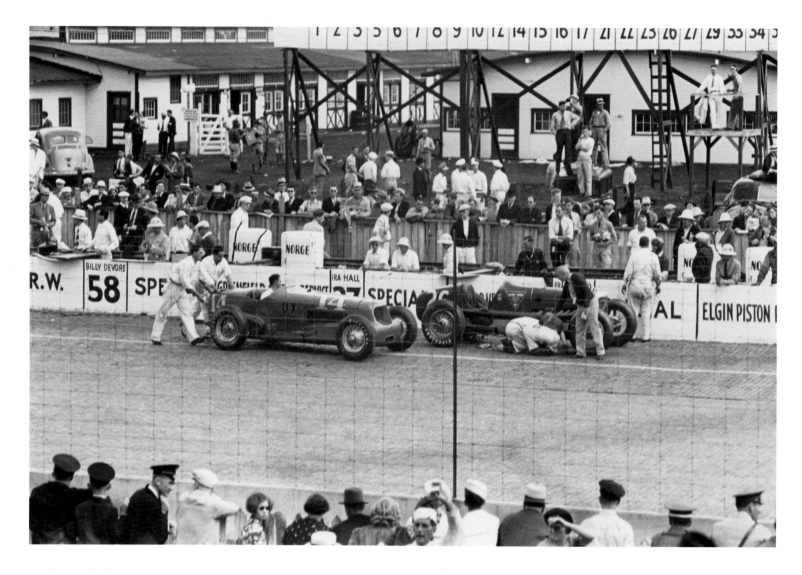

Automobile races. Indianapolis. May, 1938.

LC-USF 33–2750-M2 *Arthur Rothstein.*

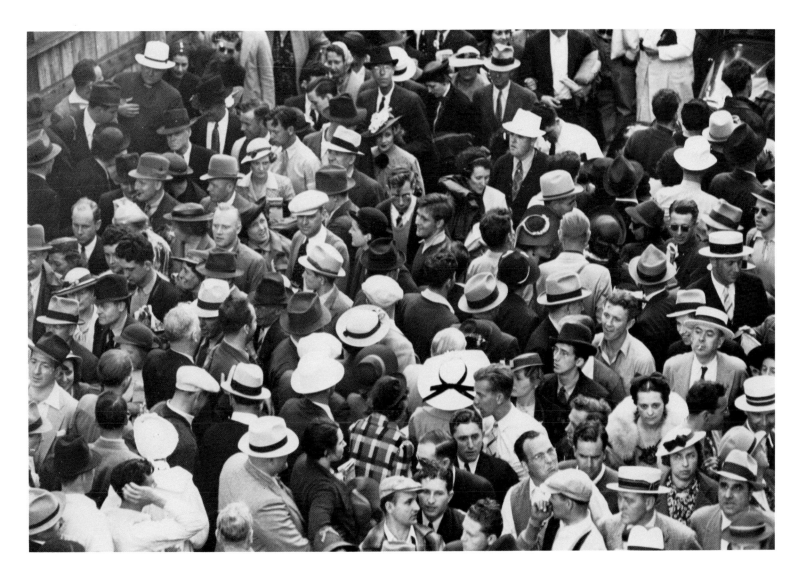

Crowds at the automobile races. Indianapolis. May, 1938.

LC-USF 33–2721-M5 *Arthur Rothstein.*

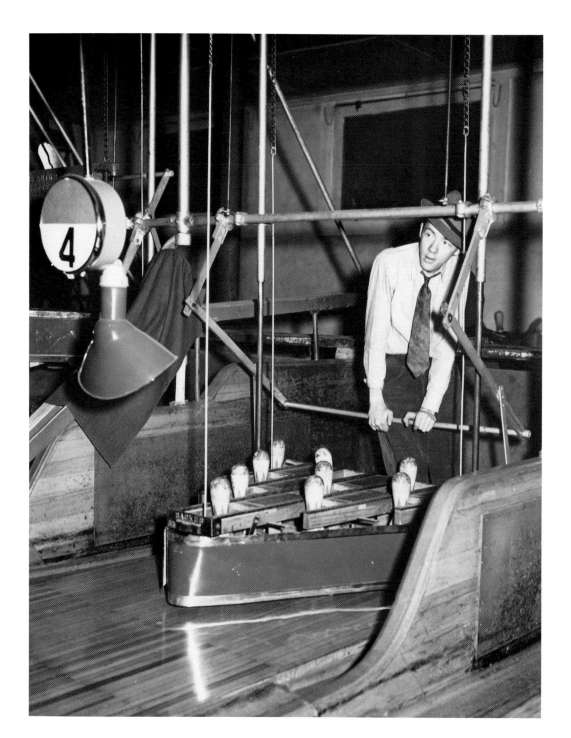

Pin boy in a bowling alley.
Clinton. February, 1940.
LC-USF 34–39484-D
Arthur Rothstein.

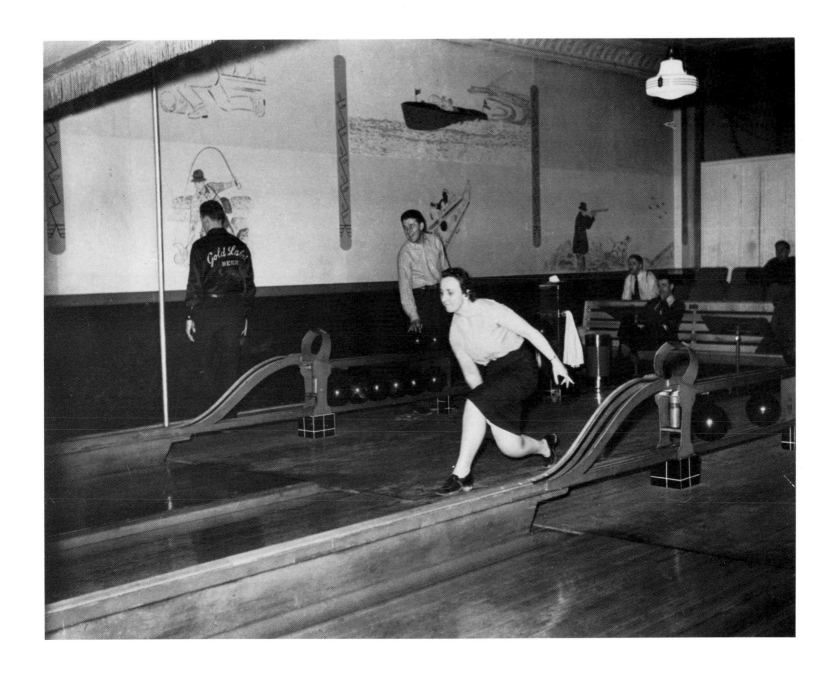

Bowling alley. Clinton. February, 1940. LC-USF 34–29495-D *Arthur Rothstein.*

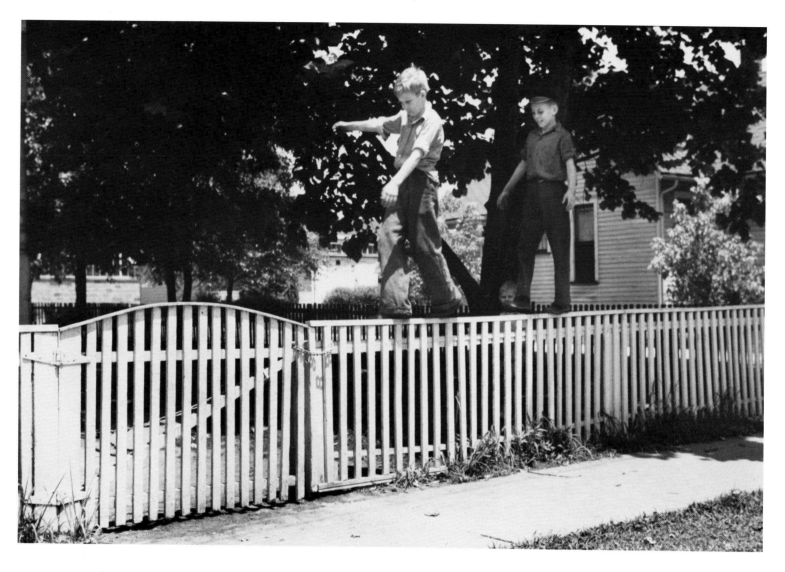

Boys walking on a fence. Washington. July, 1941. LC-USF 33–16106-M1 *John Vachon.*

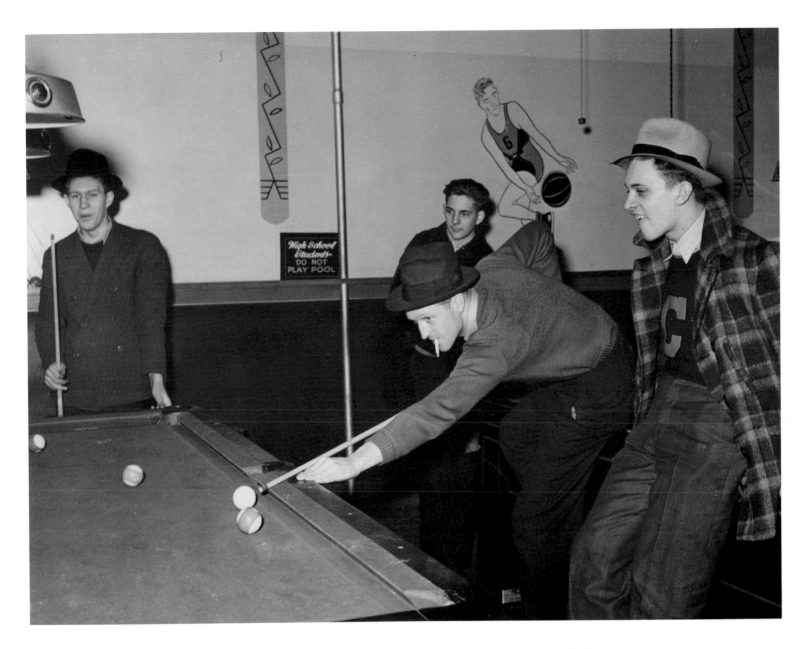

High school students playing pool. Clinton. February, 1940. LC-USF 34–29500-D *Arthur Rothstein.*

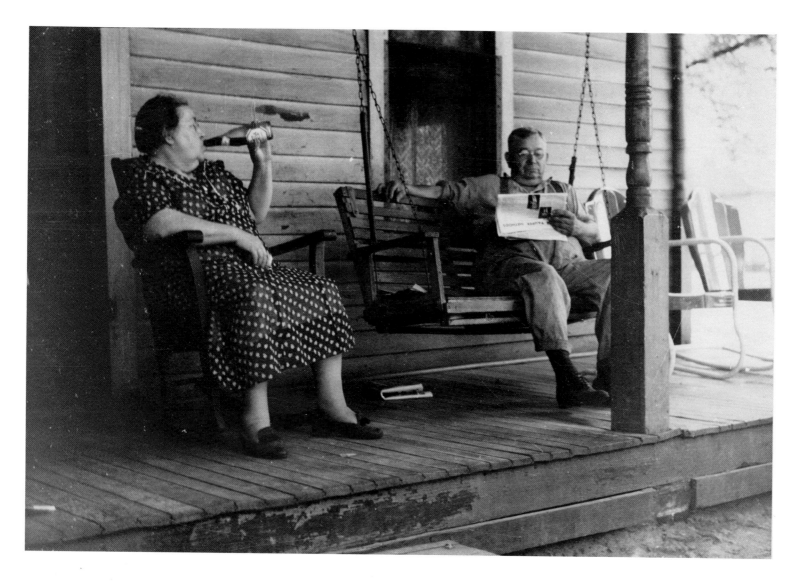

Sunday afternoon. Vincennes. July, 1941.
LC-USF 33–16089-M1 *John Vachon.*

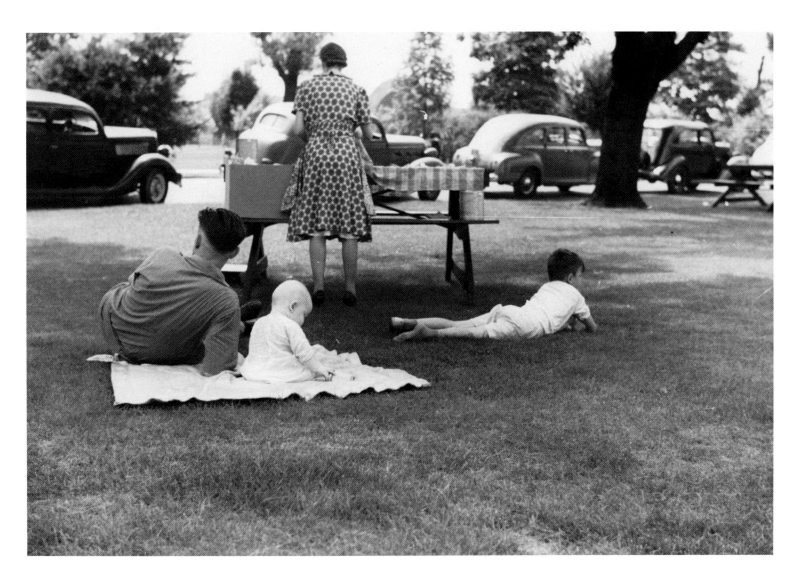

Picnickers. Vincennes. July, 1941.
LC-USF 33–16130-M2 *John Vachon.*

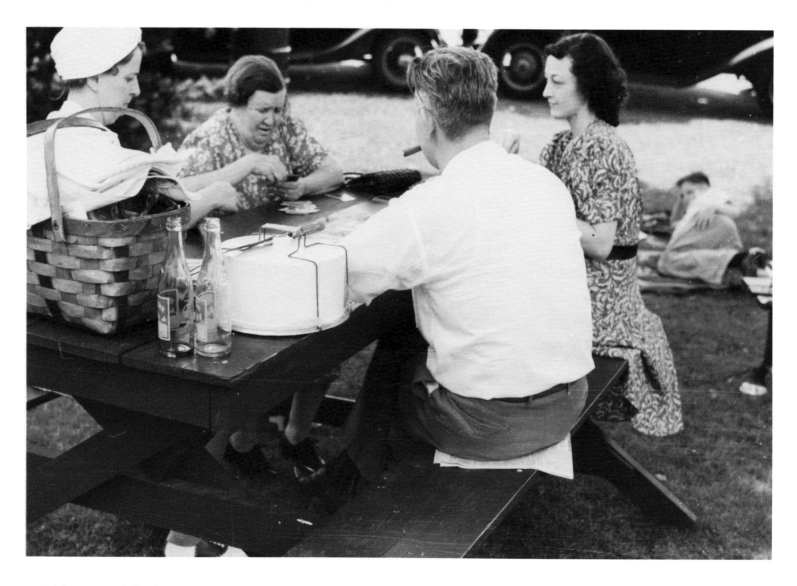

Bridge game following a Sunday afternoon picnic. Vincennes. July, 1941.
LC-USF 33–16129-M1 *John Vachon.*

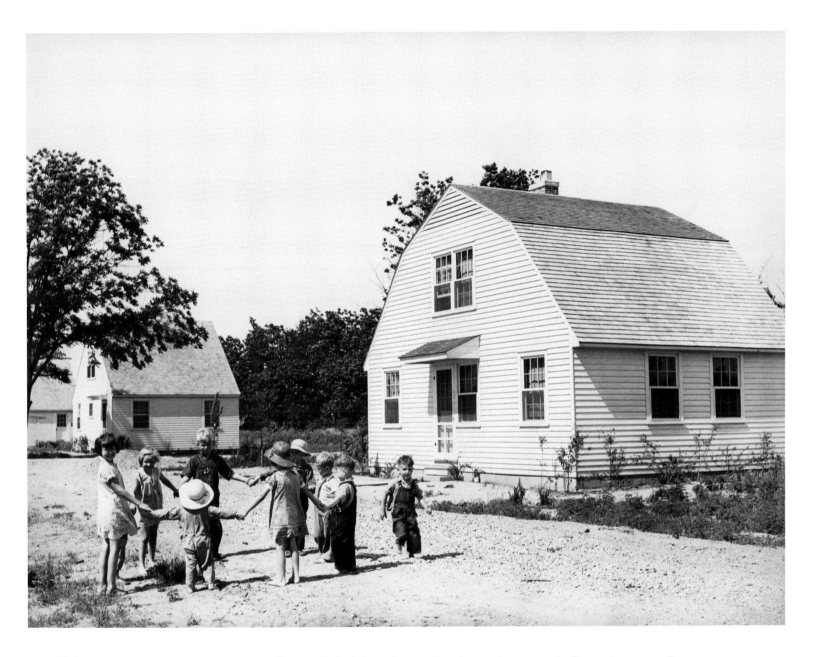

Children. Wabash Farms, a U.S. Resettlement Administration project in southwestern Indiana. June, 1938.
LC-USF 34–26358-D *Arthur Rothstein*.

Transportation

THE FSA COLLECTION provides abundant evidence of the role of the automobile in twentieth-century America. Highway signs, roadside diners, and billboards were frequent FSA subjects as were the cars and trucks which replaced horse-drawn vehicles. By the 1930s car ownership had become "one of the most depression-proof elements" in American life. The ratio of motor vehicles to people in Indiana was 1:3.4 in 1940, suggesting that most Hoosier families possessed a car. However, during this decade, Indiana saw the demise of several distinctive automobiles manufactured in the state, including the Marmon, Cord, and Stutz Bearcat. The classic image by John Vachon presents a 1935 Chevrolet in front of the 1826 Old Cathedral in Vincennes.

The other selections feature two other kinds of transportation that were important in these years: the railroad and the bus. Both sequences were shot during the war years when gasoline rationing encouraged the use of public transportation. In January 1943 Jack Delano traveled to the nation's railroad center, Chicago. His photographs of Indiana were taken on the Indiana Harbor Belt Railway, a switching operation that was a subsidiary of the New York Central. The eastern terminus of the Harbor Belt was Hammond. In nearby Gibson, the YMCA operated a facility that provided sleeping quarters, meals, and recreation for the railroad crews. Delano spent a typical twelve-hour work day on the Harbor Belt as trains were switched from railroad yard to railroad yard. He slept overnight at the Gibson YMCA where he was awakened at 5:00 a.m. by the "caller." Delano reflected on the abrupt stops and the lesson he learned from bitter experience: "Don't stand up in the caboose unless you hold onto something; otherwise you and your camera may go flying thru the rear end of the train."

Esther Bubley, who was employed by the Office of War Information, took several bus trips through the Midwest. In September 1943, she traveled across Indiana from Chicago to Cincinnati on the Greyhound. Her pictures of that trip include men in uniform with their loved ones. The waiting passengers in the Indianapolis bus station display a relaxed calm. The final photograph, a couple saying goodbye, is a touching image of a nation at war.

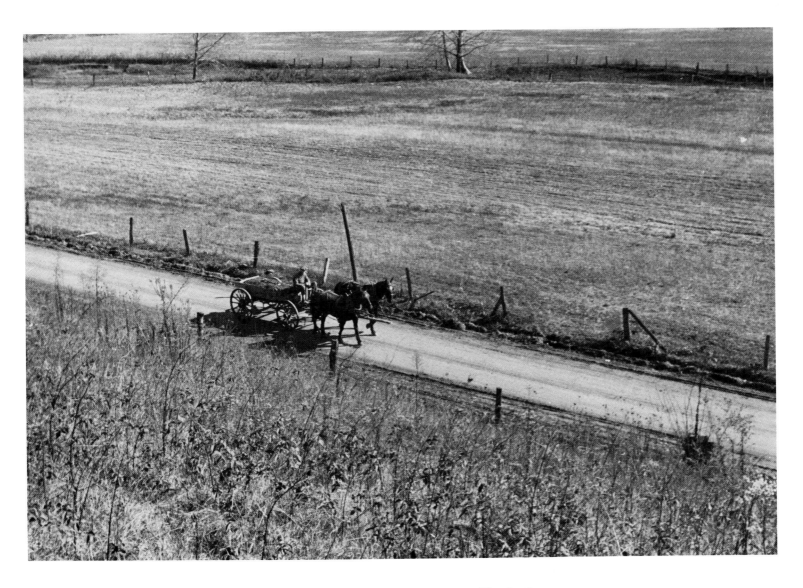

Abandoned farm land. Brown County. April, 1936. LC-USF 33–4052-M2 *Theodor Jung.*

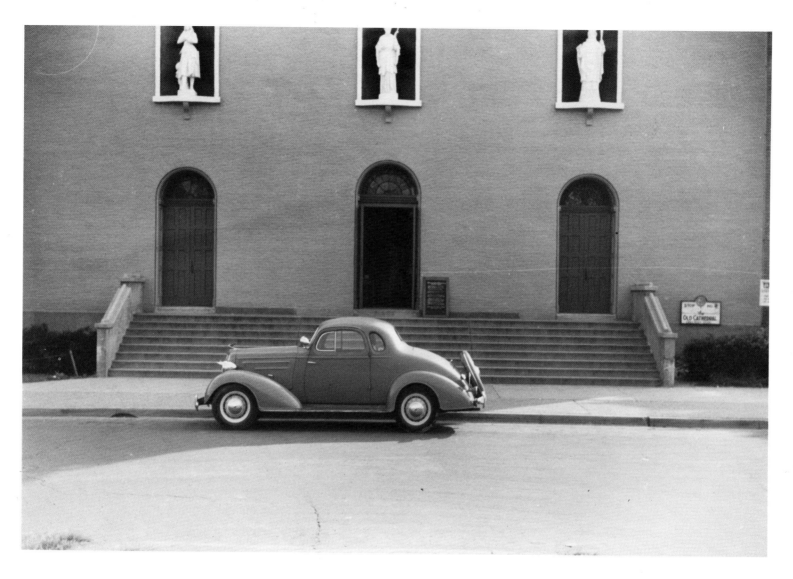

Old Cathedral. Vincennes. July, 1941.
LC-USF 33–16091-M2 *John Vachon.*

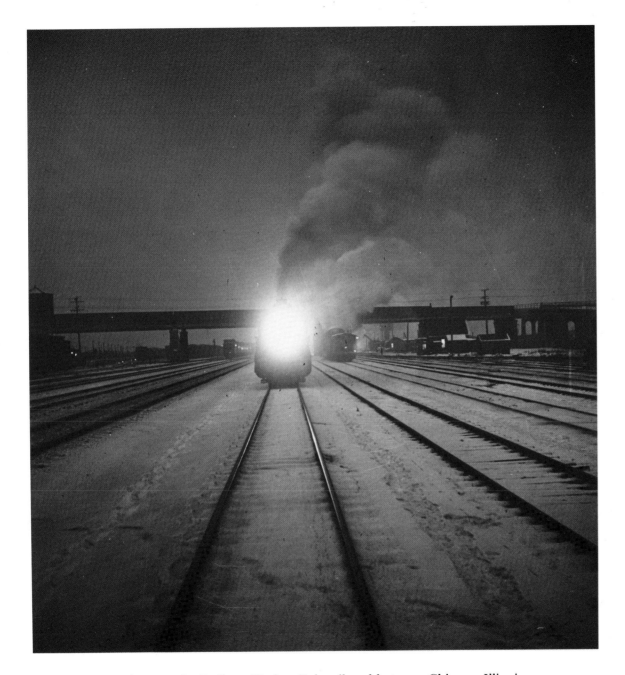

Freight operations on the Indiana Harbor Belt railroad between Chicago, Illinois, and Hammond. At 8:45 p.m. the train arrives at its destination. January, 1943. LC-USW 3–13887-E *Jack Delano.*

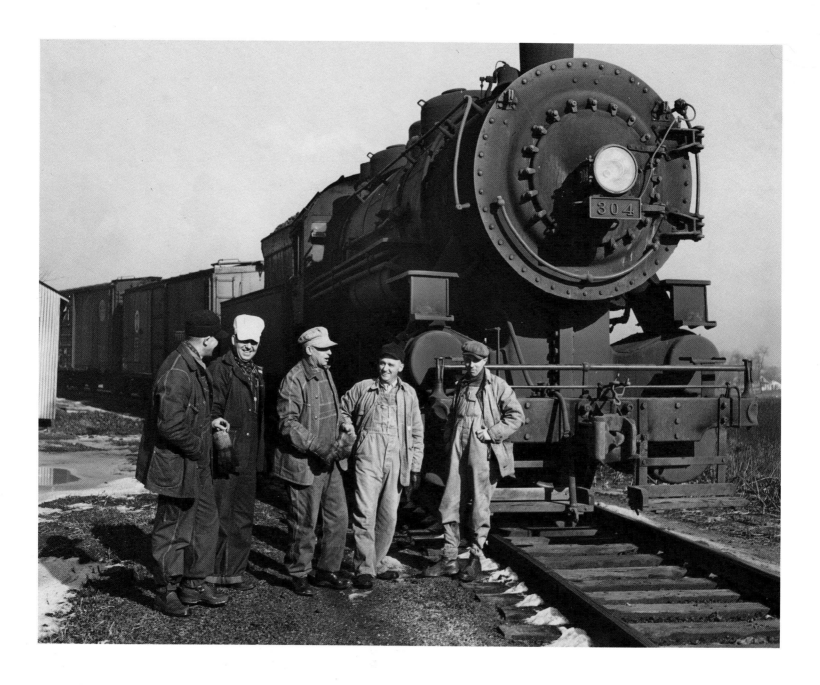

Daniel Senise and his crew with their engine in an Indiana Harbor Belt line railroad yard. Left to right: Daniel Senise, switchman, conductor and foreman; Edward Kletecka, fireman; F. K. Gwineer, engineer; E. H. Albrecht, switchman, and John McCarthy, switchman. February, 1943. LC-USW 3–16983-D *Jack Delano*.

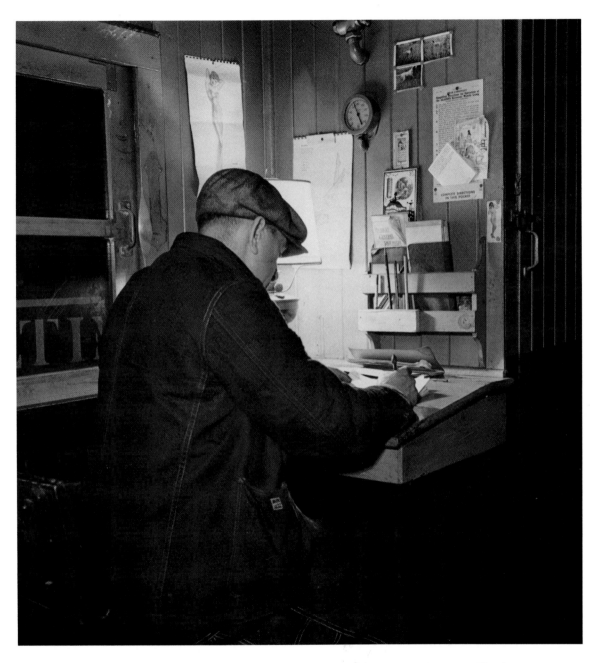

Freight operations on the Indiana Harbor Belt railroad between Chicago, Illinois, and Hammond. As soon as the train is under way, Conductor Cunningham gets to work on his bills and records. January, 1943. LC-USW 3–13849-E *Jack Delano*.

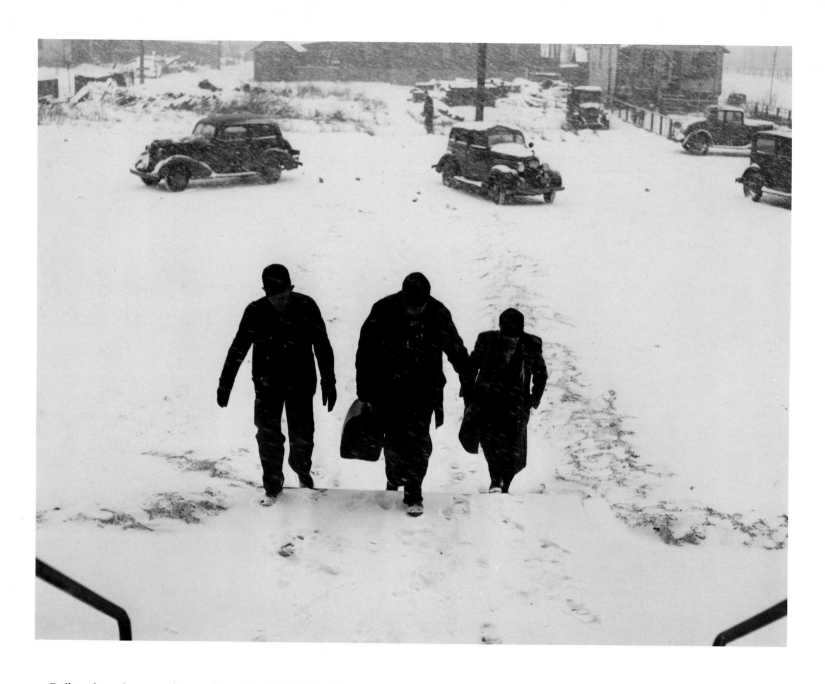

Railroad workers coming to the railroad YMCA. Gibson. January, 1943. LC-USW 3–14071-D *Jack Delano.*

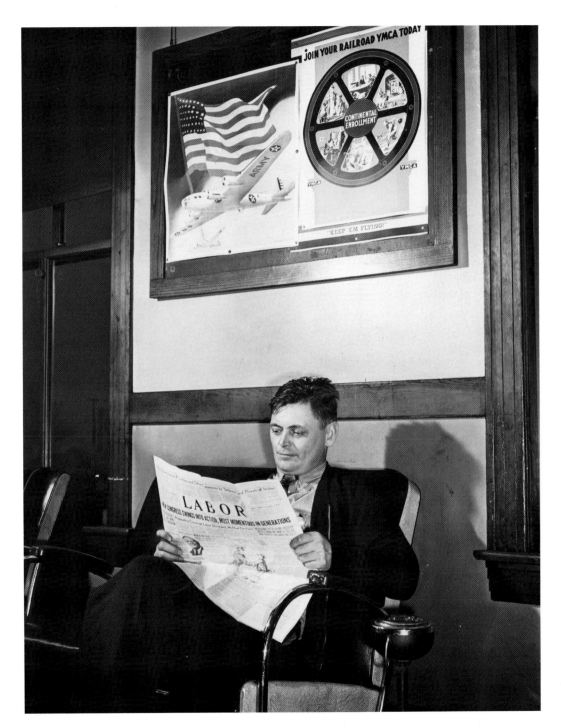

John A. Anderson, a fireman on the New York railroad, reading a railroad workers' newspaper at the railroad YMCA. His home is in Niles, Michigan, and he has been stopping regularly at the "Y" for over five years. Gibson. January, 1943.
LC-USW 3–14075-D
Jack Delano.

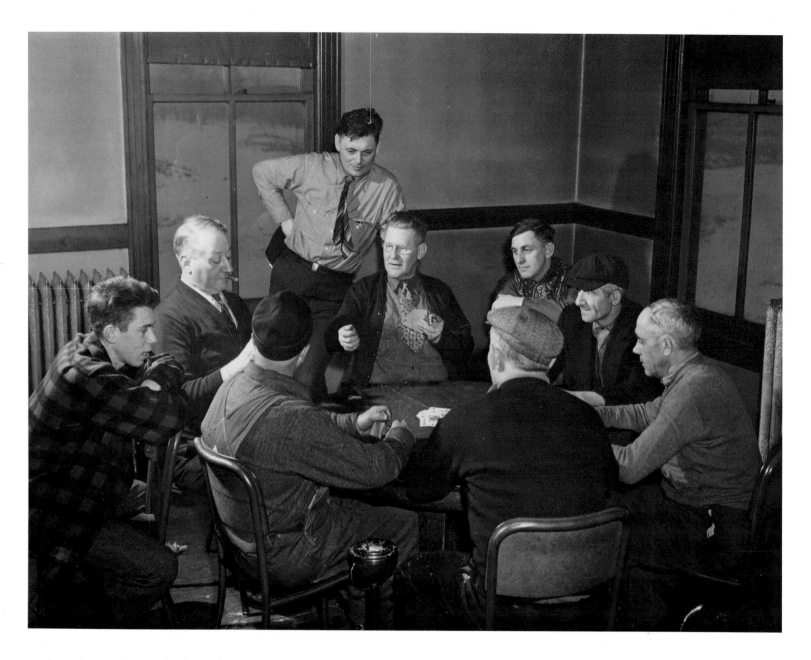

A card game is nearly always in progress in the lobby of the railroad YMCA. Gibson. January, 1943.
LC-USW 3–14076-D *Jack Delano*.

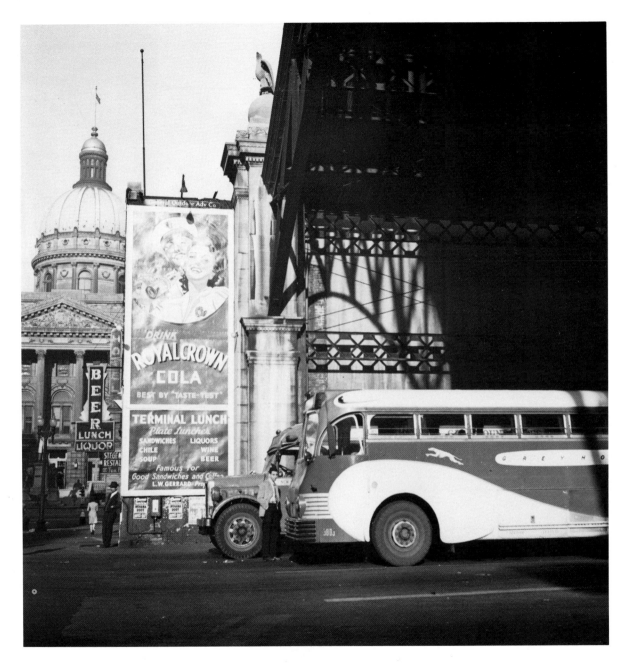

A Greyhound bus station. Indianapolis. September, 1943. LC-USW 3–37756-E *Esther Bubley*.

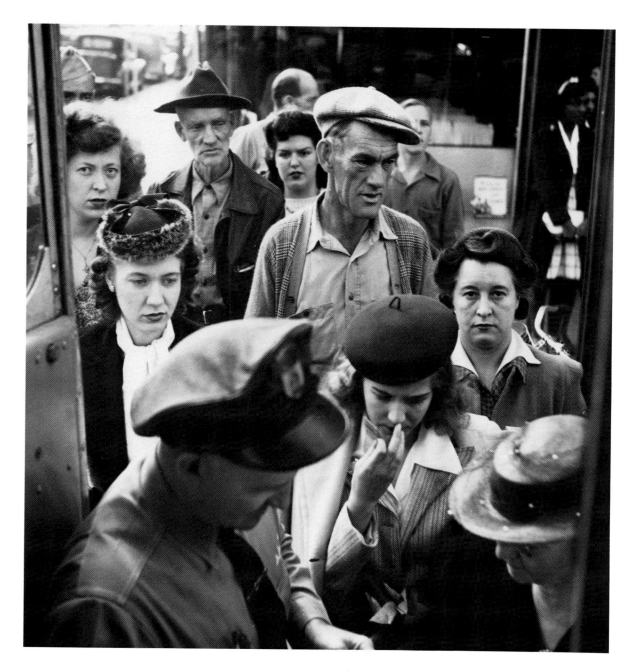

People boarding a Greyhound bus at a small town between Chicago, Illinois, and Cincinnati, Ohio. September, 1943. LC-USW 3–37709-E *Esther Bubley.*

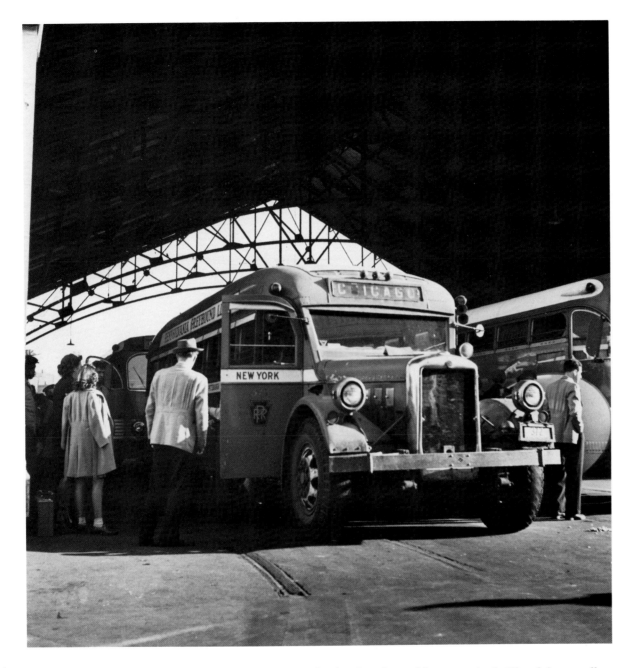

An old type bus being boarded by passengers in the Greyhound bus terminal. The drivers call this type of bus a "dive bomber." These buses are about ten years old and have been completely rebuilt. Indianapolis. September, 1943. LC-USW 3–37757-E *Esther Bubley.*

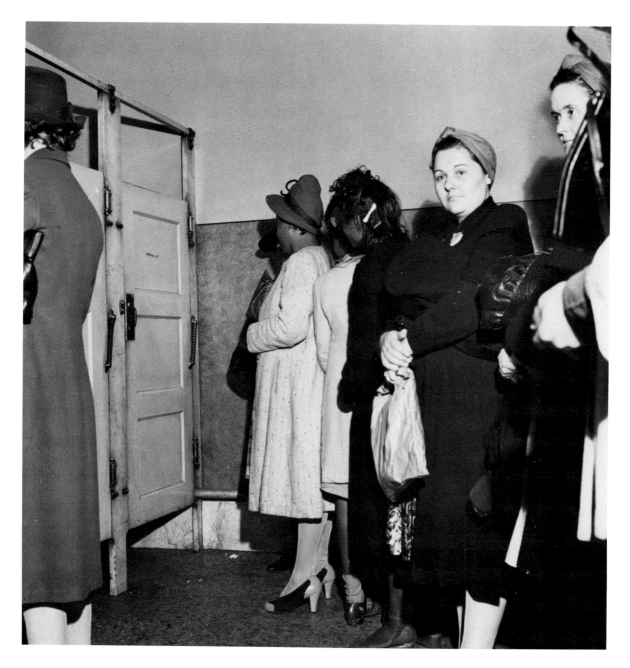

Bus passengers waiting in line to use the free toilet in the ladies' restroom at the Greyhound bus terminal. Indianapolis. September, 1943. LC-USW 3-37751-E *Esther Bubley.*

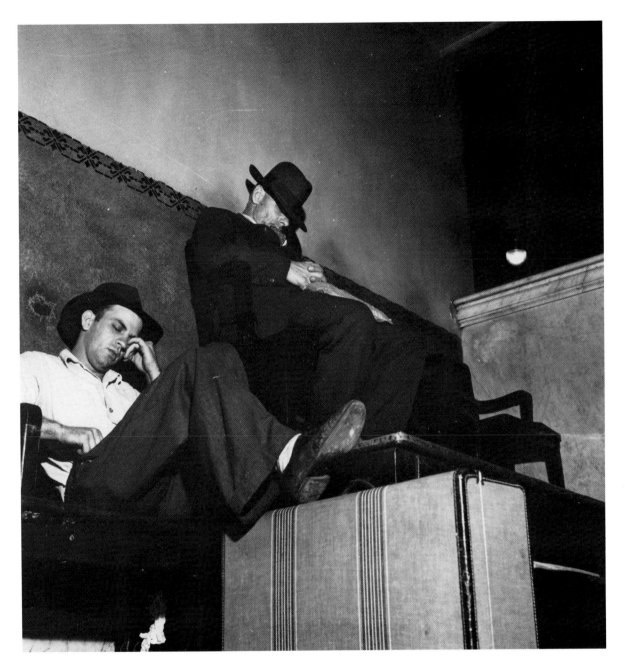

The waiting room of the Greyhound bus terminal at 5:30 a.m. Indianapolis.
September, 1943.LC-USW 3–37739-E *Esther Bubley*.

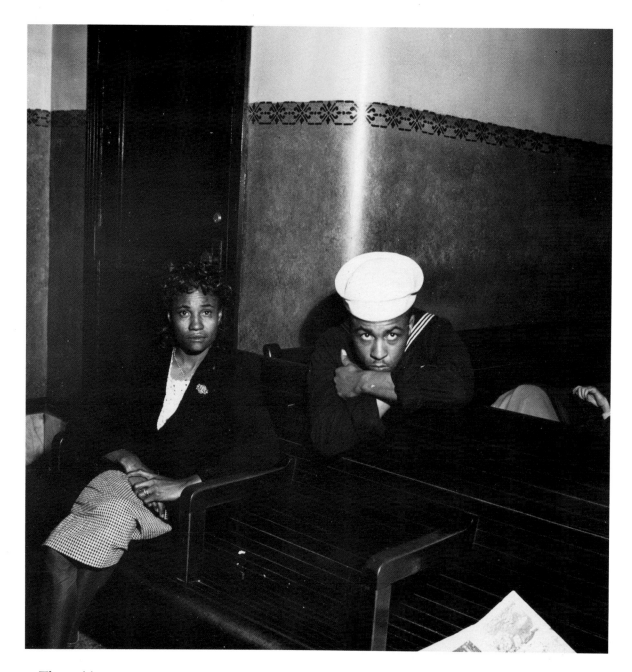

The waiting room of the Greyhound bus terminal at 5:30 a.m. Indianapolis. September, 1943.
LC-USW 3–37742-E *Esther Bubley.*

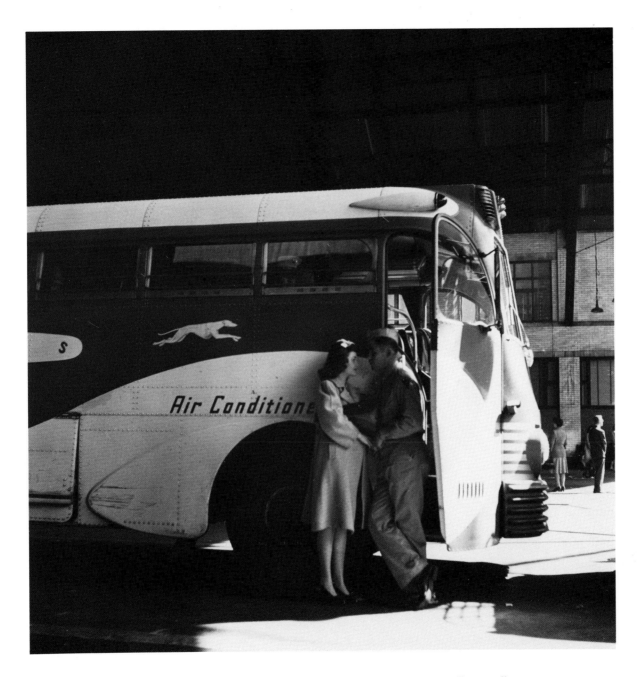

A soldier and a girl saying goodbye at the Greyhound bus station. Indianapolis.
September, 1943. LC-USW 3–37761-E *Esther Bubley.*

World War II

WORLD WAR II brought profound changes to the nation. The forces of urbanization and industrialization were accelerated as America mobilized for total war. More than 300,000 Hoosiers joined the armed forces to defeat the Axis foes; those unable to serve in the military supported the war effort here at home. Farm workers left the countryside for jobs in the cities and built an economy which ignored fears of a return of the depression and brought about a new era of postwar prosperity.

The war effort in Indiana centered on production; as a result, the Hoosier state led the nation in war facilities per capita and in new munitions plants. These facilities were concentrated in cities: Indianapolis, Fort Wayne, South Bend, Evansville, Gary, and Hammond. The Pullman Standard Company sleeping car plant in Hammond, which had been idle since 1930, was converted into a production facility for munitions, tanks, and gun assemblies. Other plants produced tanks, airplanes, and boats. In southeastern Indiana, Charlestown became a boom town as the federal government constructed the world's largest gunpowder plant. The Indiana Ordnance Works was designed, built, and operated by the DuPont Chemical Company. During the war this plant produced more than one and a half billion pounds of smokeless powder. The photographs of the trailer camp and the highway overpass give the viewer an idea of the crowded conditions experienced by the construction force, which reached a peak of more than 26,000 workers.

In Martin County, the task of removing marginal land from agricultural production was resolved with the building of the Crane Naval Ammunition Depot. More than 44,000 acres, almost one-fourth of the county, was included in this large military installation. The uprooting of Martin County residents had begun in the mid–1930s with flood-control and conservation projects. Given the magnitude of the project at Crane, a residue of bitterness toward the federal government lingered for many years in this part of the state.

Jack Delano's photographs of the U.S. Army Chaplains' School at Fort Benjamin Harrison in Indianapolis provide an ironic comment on the experience of war. Clergymen are shown preparing themselves physically, mentally, and spiritually to serve their nation and their God in a time of war. The photographs are of the first of four classes prepared in a curriculum that included first aid, topography, physical conditioning, military law, and defense against chemical warfare. Later in 1942 the Chaplains' School was moved to Harvard University. Delano's images convey also the unity of the war effort by depicting the interdenominational and interracial setting of the Chaplains' School. The pace of desegregation was hastened by a war fought to combat the totalitarian racism of Nazi Germany and Japan. After World War II, the armed forces were one of the key institutions in breaking down patterns of discrimination. The poignant photograph of the graduating class is an apt portrait of the strength and character of the American people and an appropriate closing photograph for this book.

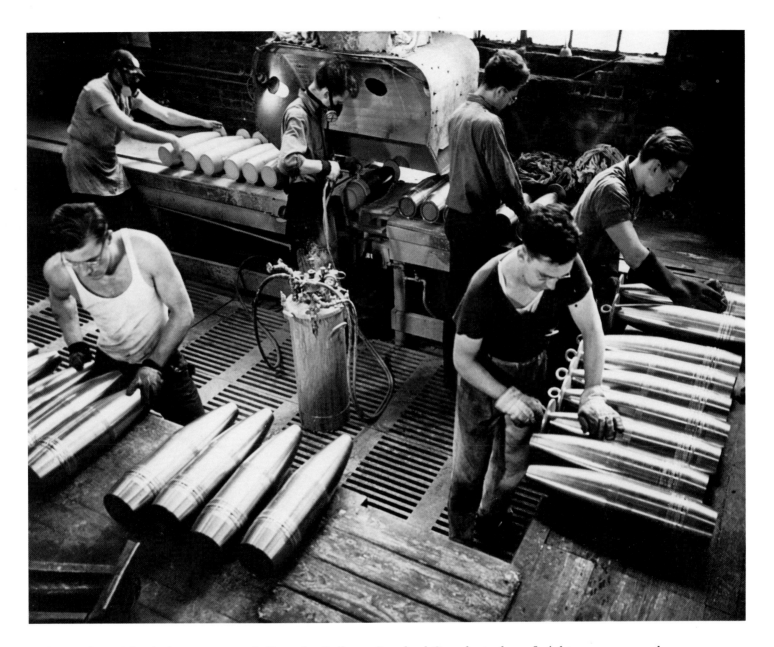

Inspecting and painting 155 mm. shells at the Pullman-Standard Car plant where freight cars were made.
Discs being screwed on shell nose (rt. foreg'nd) act as wheels to keep 'em rolling in straight line on production bench.
Hammond. 1942 (?). LC-USZ 62–90357 *Torkel Korling*.

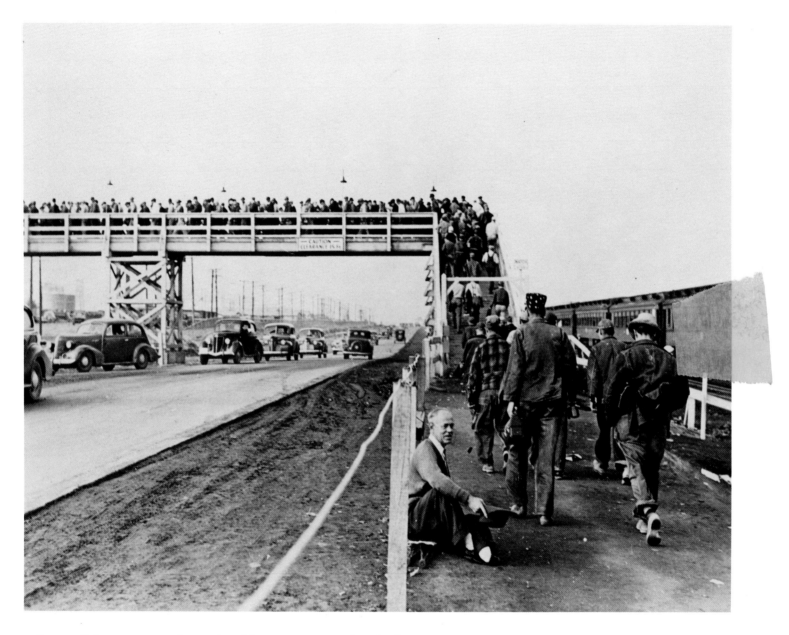

Some of the 25,000 workers who either are constructing the $75,000,000 power plant at Charlestown, or are employed in turning out smokeless powder from one of the completed sections. Charlestown. 1938–41(?). LC-(FWA)F-1463-C *Photographer unknown.*

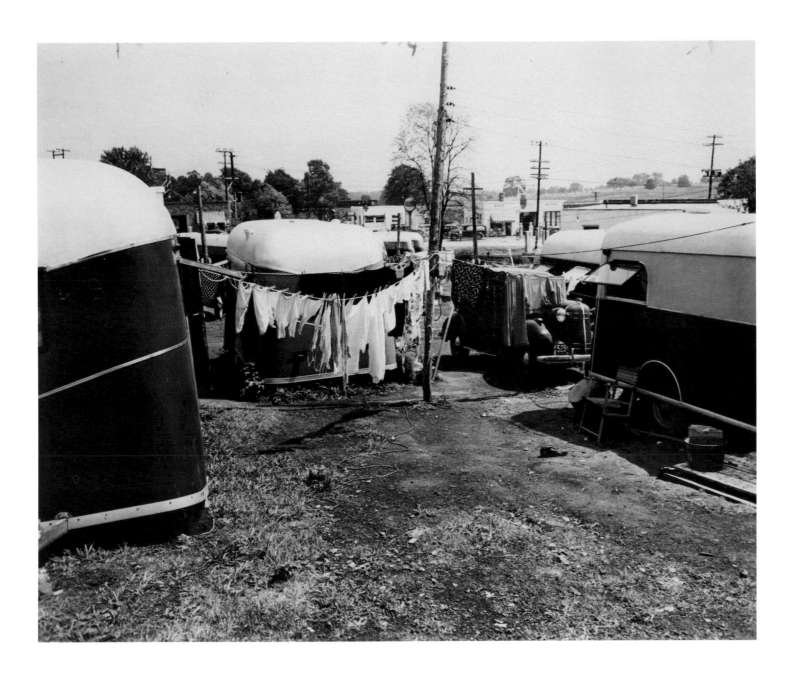

A licensed trailer camp. Charlestown. 1942(?). LC-(FWA)F-1503 *Photographer unknown.*

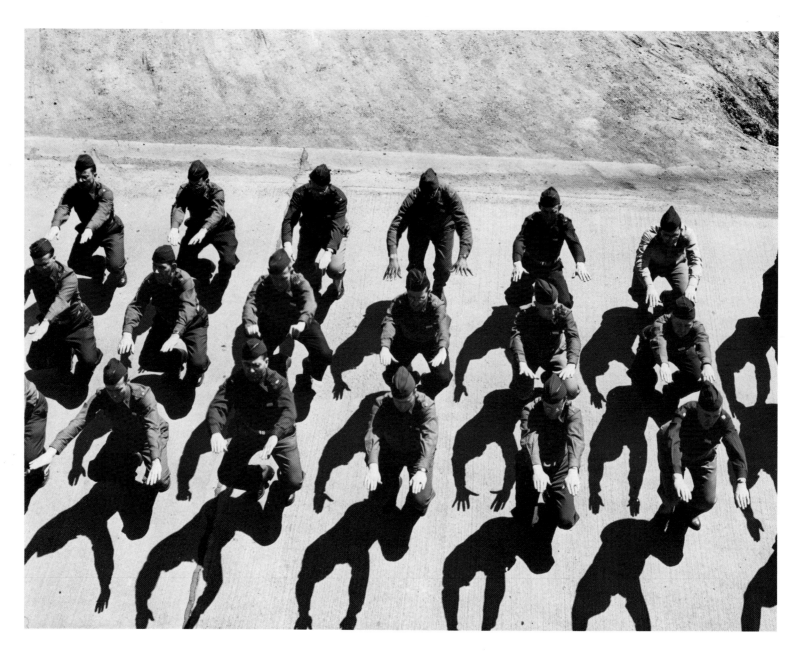

U.S. Army Chaplains' School. Setting up exercises. Fort Benjamin Harrison. April, 1942.
LC-USW 3–1683-D *Jack Delano*.

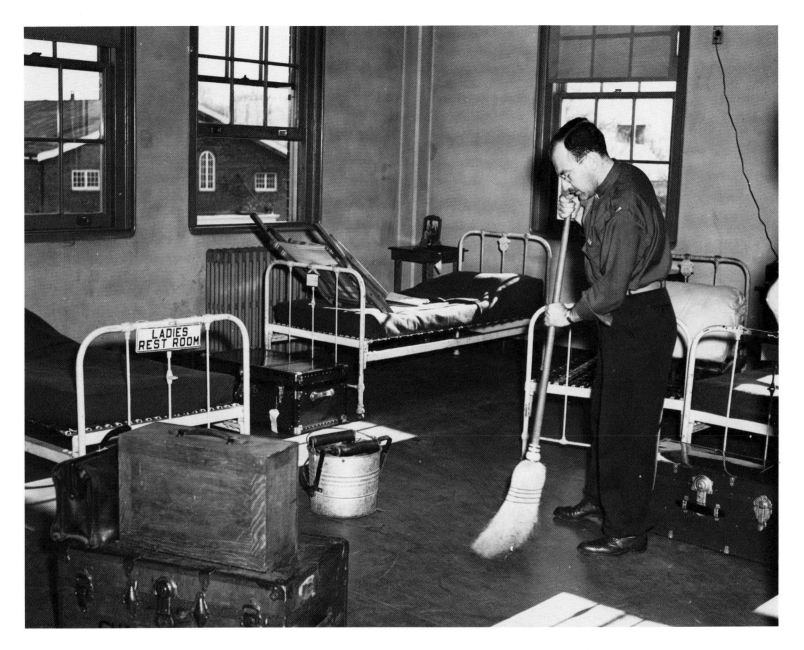

U.S. Army Chaplains' School. Chaplain David Rubin taking his turn at cleaning and sweeping the chaplains' quarters. Chaplain Rubin is of the Orthodox Jewish faith and comes from Long Island, N.Y. Fort Benjamin Harrison. April, 1942. LC-USW 3–1680-D *Jack Delano*.

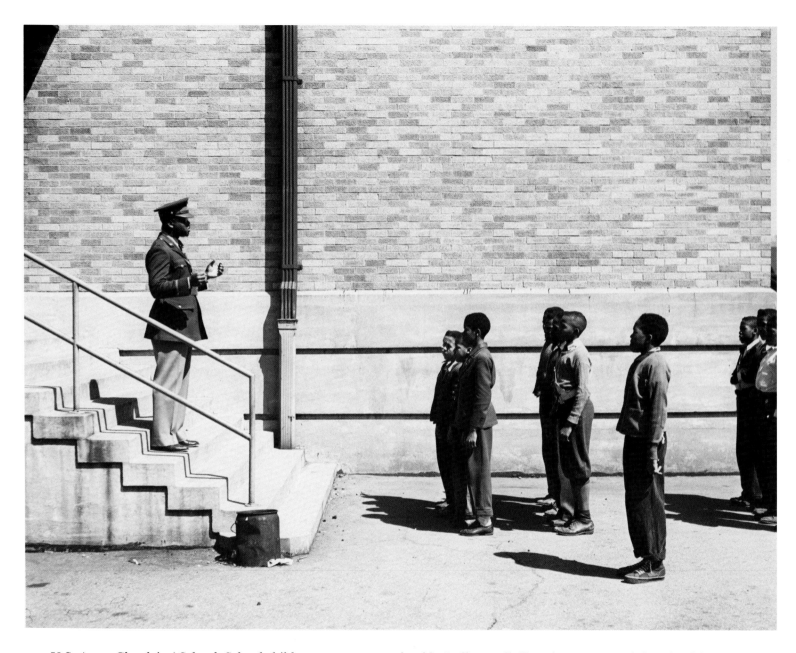

U.S. Army Chaplains' School. School children at grammar school in Indianapolis listening to a speech by Chaplain George Washington Williams, who is just graduating. Fort Benjamin Harrison. April, 1942. LC-USW 3–1667-D *Jack Delano*.

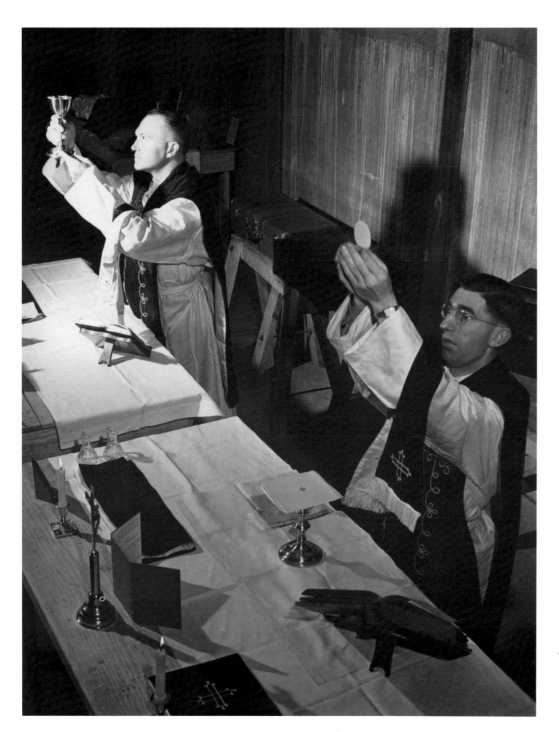

U.S. Army Chaplains' School. Chaplain Joseph W. Duane from Albany, N.Y. and Chaplain Fredric Thissen from Minnesota, Catholics, saying mass. Fort Benjamin Harrison. April, 1942.
LC-USW 3–1752-D
Jack Delano.

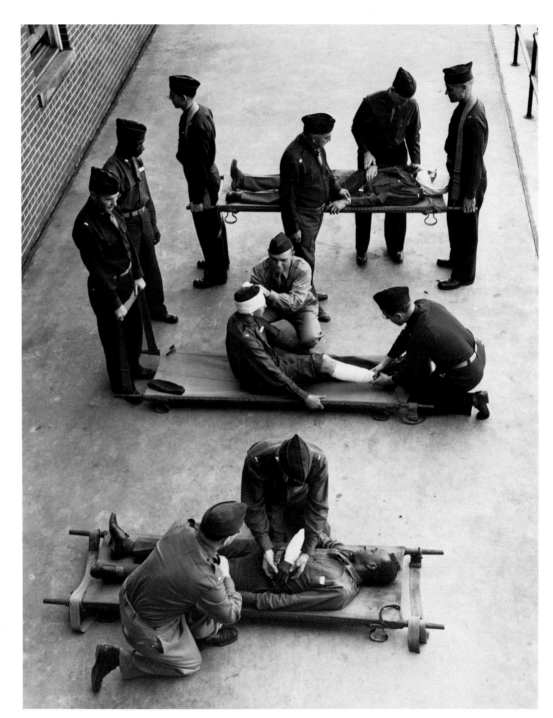

U.S. Army Chaplains' School. A class in first aid. Fort Benjamin Harrison. April, 1942.
LC-USW 3—1702-D
Jack Delano.

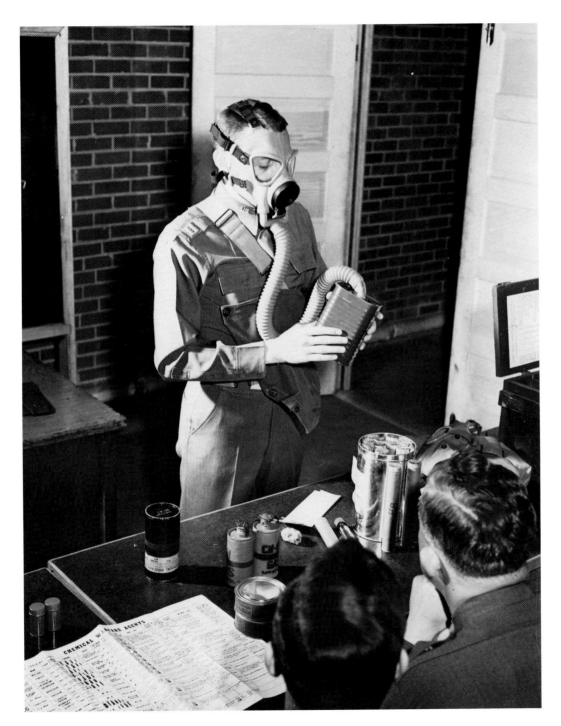

U.S. Army Chaplains' School. Capt. William W. Kitchen instructing a class in gas warfare and the use of gas masks. Fort Benjamin Harrison. April, 1942.
LC-USW 3–1662-D
Jack Delano.

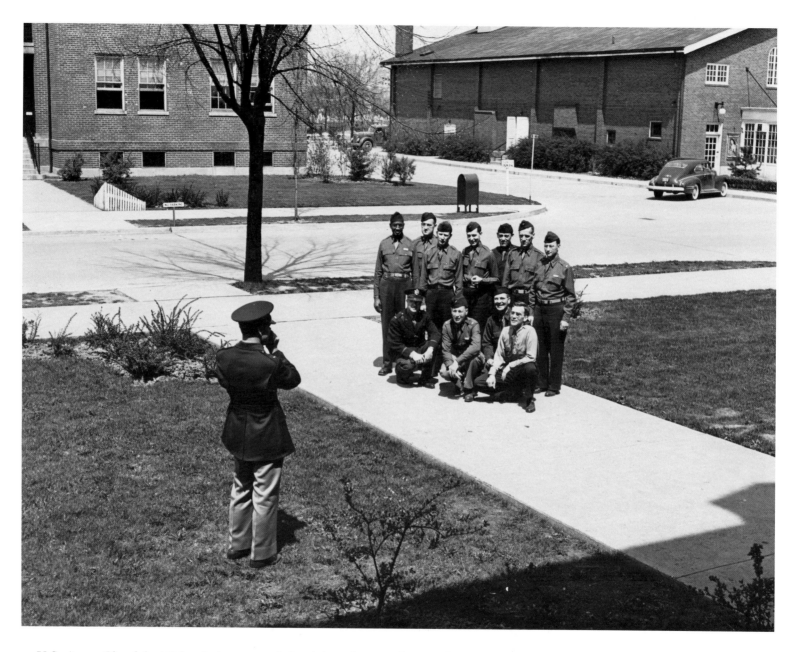

U.S. Army Chaplains' School. A group of chaplains who are about to leave for their stations having their picture taken as a memento of their days at the school. Fort Benjamin Harrison. April, 1942. LC-USW 3–1800-D *Jack Delano*.

BIBLIOGRAPHY

Anderson, James C., ed. *Roy Stryker: The Humane Propagandist.* Louisville: Photographic Archives, University of Louisville, 1977.

Anderson, Sherwood. *Home Town.* New York: Alliance Book Company, 1940.

Baker, Ronald L. and Marvin Carmony. *Indiana Place Names.* Bloomington: Indiana University Press, 1975.

Baldwin, Sidney. *Poverty and Politics: The Rise and Decline of the Farm Security Administration.* Chapel Hill: The University of North Carolina Press, 1968.

Black, Patti Carr, ed. *Documentary Portrait of Mississippi: The Thirties.* Jackson: University Press of Mississippi, 1982.

Blackburn, George M. "The Hoosier Arsenal." Ph.D. dissertation, Indiana University, 1956.

Bloemker, Al. *500 Miles to Go: The Story of the Indianapolis Speedway.* New York: Coward-McCann, 1961.

Bower, Stephen E. *The History of Fort Benjamin Harrison, 1903–1982.* Indianapolis: Command History Office, Ft. Benjamin Harrison, 1984.

Brannan, Beverly W. and David Horvath, eds. *A Kentucky Album: Farm Security Administration Photographs, 1935–1943.* Lexington: University Press of Kentucky, 1986.

Bustin, Dillon. *If You Don't Outdie Me: The Legacy of Brown County.* Bloomington: Indiana University Press, 1982.

Carr, Carolyn Kinder. *Ohio: A Photographic Portrait 1935–1941.* Akron: Akron Art Institute, 1980.

Cavnes, Max Parvin. *The Hoosier Community at War.* Bloomington: Indiana University Press, 1961.

Conkin, Paul K. *Tomorrow A New World: The New Deal Community Program.* Ithaca: Cornell University Press, 1959.

Decatur Daily Democrat. July 19, 1963; September 4, 5, 6, 1980.

Dixon, Penelope. *Photographers of the Farm Security Administration: An Annotated Bibliography, 1930–1980.* New York: Garland Publishing, 1983.

Doud, Richard K. Interviews with Jack Delano, Theodor Jung, Dorothea Lange, Russell Lee, Carl Mydans, Arthur Rothstein, and John Vachon, in 1964 and 1965. Transcripts at the Archives of American Art, Smithsonian Institution, Washington, D.C.

Frederick, Robert Allen. "Colonel Richard Lieber, Conservationist and Park Builder: The Indiana Years." Ph.D. dissertation, Indiana University, 1960.

Gates, Paul Wallace. "Land Policy and Tenancy in the Prairie Counties of Indiana." *Indiana Magazine of History,* XXXV, 1–26.

Hurley, F. Jack. *Portrait of a Decade: Roy Stryker and the Development of Documentary Photography in the Thirties.* Baton Rouge: Louisiana State University Press, 1972.

Hurley, F. Jack. *Russell Lee: Photographer.* Dobbs Ferry, New York: Morgan and Morgan, 1978.

Indiana Clipping File, Indiana State Library.

Johnson, Brooks. *Mountaineers to Main Streets: The Old Dominion as seen through the Farm Security Administration Photographs.* Norfolk: The Chrysler Museum, 1985.

Johnson, Leland R. *The Falls City Engineers: A History of the Louisville District Corps of Engineers, United States Army.* Louisville: Louisville District Corps of Engineers, 1974.

Lee, Russell. Telephone Interview. Austin, Texas. April 4, 1986.

MacLeish, Archibald. *Land of the Free.* New York: Harcourt, Brace and Company, 1938.

Madison, James H. *Indiana through Tradition and Change: A History of the Hoosier State and Its People, 1920–1945.* Vol. 5 of *The History of Indiana.* Indianapolis: Indiana Historical Society, 1982.

Madison, James H. *The Indiana Way: A State History.* Bloomington: Indiana University Press and Indiana Historical Society, 1986.

Mathis, Ray. "A History of Brown County." M.A. thesis, Indiana University, 1936.

Meltzer, Milton. *Dorothea Lange: A Photographer's Life.* New York: Farrar, Straus, and Giroux, 1978.

Moore, H.E. and O.G. Lloyd. *The Back-to-the-Land Movement in Southern Indiana.* Lafayette: Purdue University Agricultural Experiment Station Bulletin, No. 409, 1936.

Ohrn, Karin Becker. *Dorothea Lange and the Documentary Tradition.* Baton Rouge: Louisiana State University Press, 1980.

O'Neal, Hank. *A Vision Shared: A Classic Portrait of America and Its People, 1935–1943.* New York: St. Martin's Press, 1976.

Perry, J. Richard. *Preliminary Survey of County Planning Problems in Martin County, Indiana.* Indianapolis: State Planning Board and the Works Project Administration, 1936.

Plattner, Steven W. *Roy Stryker: U.S.A., 1943–1950: The Standard Oil (New Jersey) Photography Project.* Austin: University of Texas Press, 1983.

Puckett, John Rogers. *Five Photo-Textual Documentaries from the Great Depression.* Ann Arbor: UMI Research Press, 1984.

Records of the Farm Security Administration. Record Group 96. National Archives. Washington, D.C.

Records of the Secretary of the Interior. Record Group 48. National Archives. Washington, D.C.

Reid, Robert L., ed. *The Great Flood of '37: 50th Anniversary.* Evansville, Indiana: The Courier Company, 1987.

Riker, Dorothy, comp. *The Hoosier Training Ground: A History of Army and Navy Training Centers, Camps, Forts, Depots, and Other Military Installations within the State Boundaries during World War II.* Bloomington: Indiana University Press, 1952.

Rothstein, Arthur. *Arthur Rothstein: Words and Pictures.* New York: American Photographic Book Publishing Co., 1979.

Steichen, Edward. *The Bitter Years: 1934–1941.* New York: The Museum of Modern Art, 1962.

Stoeckle, John, M.D., and George Abbott White. *Plain Pictures of Plain Doctoring: Vernacular Expression in New Deal Medicine and Photography.* Cambridge: The MIT Press, 1985.

Stryker, Roy E. *Papers of Roy E. Stryker, 1912–1972.* Louisville: University of Louisville Photographic Archives, Ekstrom Library. [Microfilm.]

Stryker, Roy E., and Paul H. Johnstone. "Documentary Photographs," in *The Cultural Approach to History.* Edited by Caroline F. Ware. New York: Columbia University Press, 1940.

Stryker, Roy E., and Nancy C. Wood. *In This Proud Land: America, 1935–1943, As Seen in the FSA Photographs.* New York: Galahad Books, 1973.

Sylvester, Lorna Lutes. "Down in the Hills o' Brown County: Photographs by Frank M. Hohenberger," *Indiana Magazine of History*, LXXI, 205–244, LXXII, 21–62.

Taylor, Carl C., Helen R. Wheeler, and E. L. Kirkpatrick. *Disadvantaged Classes in American Agriculture.* Washington, D.C.: Farm Security Administration and the Bureau of Agricultural Economics, Social Research Report No. VIII, 1938.

U.S. Bureau of the Census. *Sixteenth Census: Agriculture, Indiana, 1940.* Washington, D.C.: Government Printing Office, 1941.

Valle, James E. *The Iron Horse at War.* Burbank, California: Howell-North, 1977.

Ware, Harold M. and Webster Powell. "Planning for Permanent Poverty: What Subsistence Farming Really Stands For," *Harper's Monthly*, CLXX, 513–524.

Washington, D.C. National Archives. Department of Agriculture, Farm Security Administration, Record Group 96.

White, George Abbott. "Vernacular Photography: FSA Images of Depression Leisure." *Studies in Visual Communications*, IX, 53–75.

Wright, Richard, and Edwin Rosskam. *Twelve Million Black Voices: A Folk History of the Negro in the United States.* New York: Viking Press, 1941.

Writers of the Work Projects Administration. *Indiana: A Guide to the Hoosier State.* New York: Oxford University Press, 1941.

Written Records of the Farm Security Administration, Historical Section—Office of War Information, Overseas Picture Division, Washington Section. Washington, D.C.: Library of Congress, 1984. [Microfilm.]

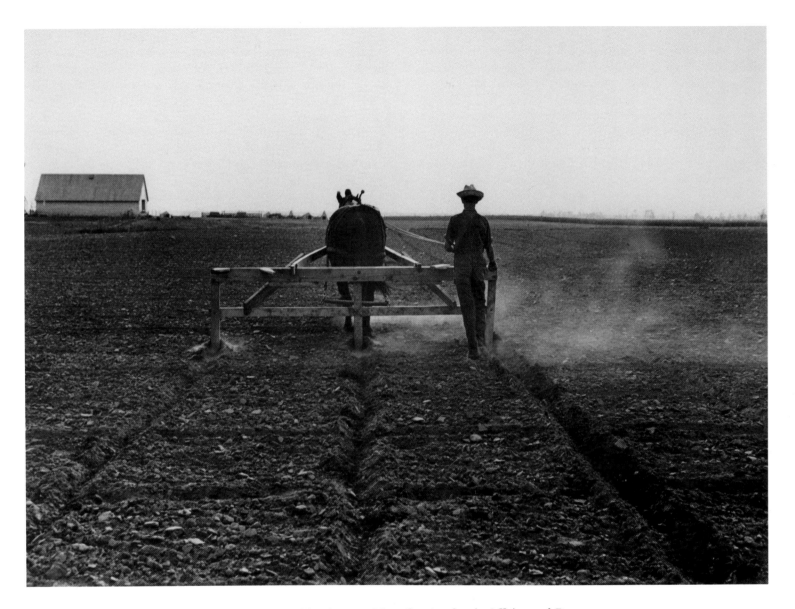

Robert L. Reid, Vice President for Academic Affairs and Professor of History at the University of Southern Indiana, Evansville, is the author of numerous articles on American history and editor of a book of photographs, *The Great Flood of '37: 50th Anniversary.*

Editor: Roberta L. Diehl
Designer: Harriet S. Curry
Production coordinator: Harriet S. Curry
Typeface: Baskerville
Typesetter: J. Jarrett Engineering, Inc.
Printer: Malloy Lithographing Co.
Binder: John Dekker & Sons